IMAGES
of America

BRISBANE

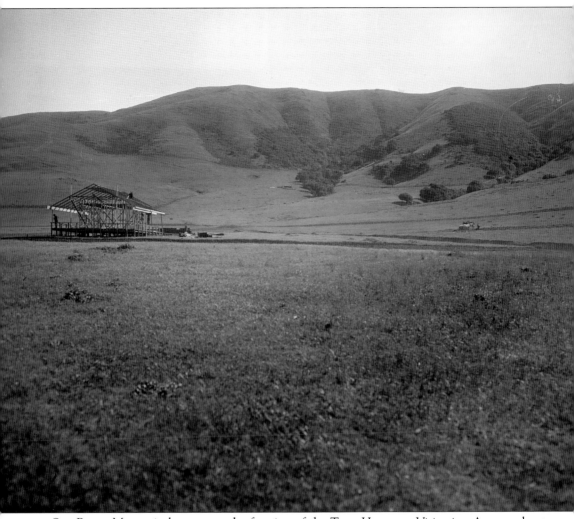

San Bruno Mountain looms over the framing of the Tract House on Visitacion Avenue about 1909. (Courtesy of San Francisco History Center, San Francisco Public Library.)

ON THE COVER: Men lay gutters along Brisbane's main street, Visitacion Avenue, around 1908. The building at 101 Visitacion Avenue is on the left. (Courtesy of San Francisco History Center, San Francisco Public Library.)

IMAGES
of America

BRISBANE

Dolores Gomez and Christy Thilmany

ARCADIA
PUBLISHING

Published by Arcadia Publishing
Charleston SC, Chicago IL, Portsmouth NH, San Francisco CA

Printed in the United States of America

Library of Congress Control Number: 2009921924

For all general information contact Arcadia Publishing at:
Telephone 843-853-2070
Fax 843-853-0044
E-mail sales@arcadiapublishing.com
For customer service and orders:
Toll-Free 1-888-313-2665

Visit us on the Internet at www.arcadiapublishing.com

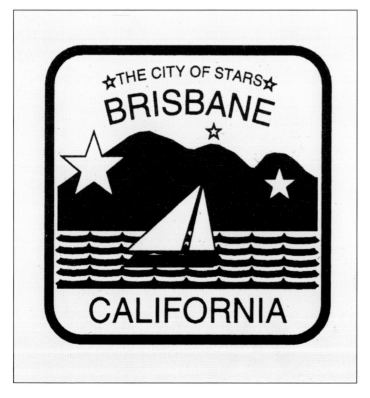

Charles Kemp, a Brisbane planning commissioner, volunteered his wife, Virginia, a talented artist, to create a logo for Brisbane after incorporation in 1961. The selected logo fully relates to Brisbane as well as San Francisco Bay, San Bruno Mountain, and of course, the Brisbane Stars that reflect the Brisbane spirit.

CONTENTS

ACKNOWLEDGMENTS

We salute the early residents and those who settled here during the Great Depression who, with hard work, began building and enhancing the town for the future generations. The World War II folks who came to work in shipyards were a diverse lot who bonded with and supported those already in Brisbane. Throughout the first half of the 1900s, hearty residents, through their own efforts, volunteered and raised money with potlucks, dances, parades, and much more, creating a spirit that truly carried the town to where it is now. Unless otherwise noted, all images appear courtesy of the Brisbane Library Historical Collection.

We would also like to acknowledge the contributions and generous help of the following organizations and people: San Mateo County Historical Society; Jim Gallian; Steve Giusti; Erin McGee, Kelly Mackewicz, Steve Rosenthal, and all the staff of the Brisbane Library; Sheri Spediacci at Brisbane City Hall; Leo, Dora, and the Allemand family; Norman Brown; Gloria Christine; Kay and Bob Rossi; Dorothy Watson; Eleanor Schmidt; Walter Hubrig; Larry Blanchard; Mansel Roland; Lillian Wilson Repetto; Joan Randrup Lininger; Harry P. Costa of Costa and Things; Jeff Shackleford; Larry Jenkins; San Bruno Mountain Watch; Anita Oroquita; John Clancy; Bill Owens; and Willie Green. We would also like thank our husbands, Johnny Gomez and John Thilmany, for their love and support.

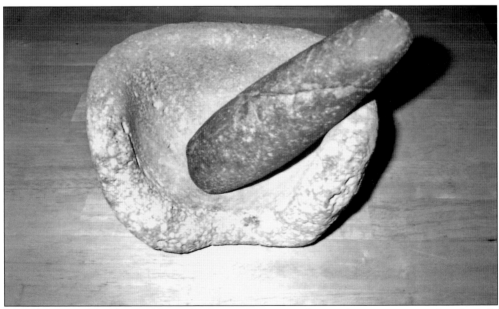

This mortar and pestle, used by early Native Americans for grinding acorns, was found while excavating for Crocker Industrial Park in the mid-1950s. The Ohlone were the people who lived in the area. After the acorn meal was fine enough, water would be poured over it to wash away the tannin so the meal could be cooked.

INTRODUCTION

Nestled in the shadow of San Bruno Mountain, Brisbane, California, lies about 10 miles south of the center of the city of San Francisco. From Native American villages to the continuing attractive small-town atmosphere, Brisbane has retained an independent spirit in a charming location on the upper San Francisco Peninsula.

Brisbane's earliest inhabitants were Native Americans known today as the Ohlone, bands of hunter-gatherers living lightly on the land in semipermanent villages such as Amuctac and Tubsinte. Among the animals they hunted were ducks, bobcats, bears, and snakes, and many insects were also food sources. They also enjoyed much bounty from San Francisco Bay, such as shellfish, fish, and sea plants. To encourage growth of the nuts and grasses they gathered for food, they would burn the slopes and valleys of San Bruno Mountain routinely.

When the Spanish came to what they called Alta or Upper California around 1769, although some resisted, many of the Ohlone were pushed off the land and into the missions. The Catholic Church, which came to own most of the land, used the slopes and valleys of San Bruno Mountain to graze their cattle. Mexico gained its independence from Spain in 1821 and carved up the former Spanish lands into land grants, one of which was awarded to an American named Jacob Leese around 1841. He became a Mexican citizen and was married to a sister of Gen. Mariano Vallejo, after whom the city of Vallejo is named. The land grant was known as Rancho Canada de La Guadalupe La Visitacion y Rodeo Viejo. The name indicated three valleys. What is now the area around central Brisbane and Crocker Industrial Park was the valley of Canada de La Guadalupe. La Visitacion is still known as Visitacion Valley. Rodeo Viejo was the valley lying along Mission Street from Daly City to where it crosses Allemany Boulevard.

The land went through several owners after Jacob Leese traded this rancho for one in Sonoma County in 1843. The remainder of the 19th century into the 20th century saw most of the area used for ranch land and dairy farming. The San Bruno Toll Road passed through the area beginning in 1860; it ran close to San Francisco Bay and connected to El Camino Real in San Bruno. At what is now the northern city limits of Brisbane at Geneva Avenue and Bayshore Boulevard, the Seven Mile House began serving travelers on the toll road in the 1880s. Part of the original building exists as a section of the present pub. A quarry on the slopes of San Bruno Mountain was established in the 1890s.

After the 1906 San Francisco earthquake, several proposals were made to develop the northern part of the San Francisco Peninsula. In 1908, a city called Vista Grande was proposed. It would encompass the areas of what are today Daly City, Colma, and Brisbane. Much opposition ensured that this never came about. At the same time, the American Realty Company subdivided what is now the central Brisbane town area. Streets were laid out, some houses erected, and a streetcar line was proposed that would take the residents into San Francisco. This new town was named the city of Visitacion.

The city of Visitacion never really attracted many settlers, and the streetcar line was never built. Over 20 years later in 1929, another real estate developer named Arthur Annis reopened the tract office built by the earlier promoters and renamed the town Brisbane to avoid confusion with the adjacent area of Visitacion Valley. There are two theories as to the origin of the name: to honor the famed journalist Arthur Brisbane, who was the highest paid newspaper editor of his day in the United States, or after Brisbane, Australia, which has similar topography.

Arthur Annis offered many lots for sale at very reasonable prices. Some monthly house payments were as low as $16, affordable even in the trying times of the Great Depression of the 1930s. Many

families began moving to Brisbane, but the population increased much more with World War II, when workers came from all over the country to work in the nearby shipyards.

Brisbane residents have fought hard to remain "fiercely independent." At one time, Brisbane was looked down upon and real estate did not hold much value compared with the rest of San Mateo County. Unincorporated Brisbane was called the "place where garbage was dumped" because the city of San Francisco would dump its raw garbage at Sierra Point, which is within the city limits of Brisbane. When rumors of urban renewal surfaced with talk of bulldozing buildings, town leaders and longtime residents fought back, resulting in the birth of the city of Brisbane, incorporated in 1961.

During the 1950s and 1960s, there were various proposals to develop San Bruno Mountain and the surrounding area. One proposal was even to shave off the top of the mountain to use as fill for San Francisco Bay. To preserve the peak, the Committee to Save San Bruno Mountain (now known as San Bruno Mountain Watch) was formed. Through their efforts, a state and county park was established, and the group continues to fight to preserve the last large open space on the northern peninsula, endangered species habitats, and significant Native American sites such as shell mounds.

In the 1980s, another of Brisbane's efforts to preserve the special nature of the town was the fight to keep a large incinerator from being built within town limits to process San Francisco garbage. Feisty Brisbane won that battle, too, again refusing to be the site of a "Dumps."

Over the years, the exceptional weather and convenient access to San Francisco have come to attract a more diverse population of differing skills and professions. The modest homes of the hardworking blue-collar settlers of the past now are joined by more upscale homes as well as several industrial parks. But the independent spirit of the past continues to make Brisbane a distinctive place, more a state of mind than a location.

One

BYGONE BRISBANE

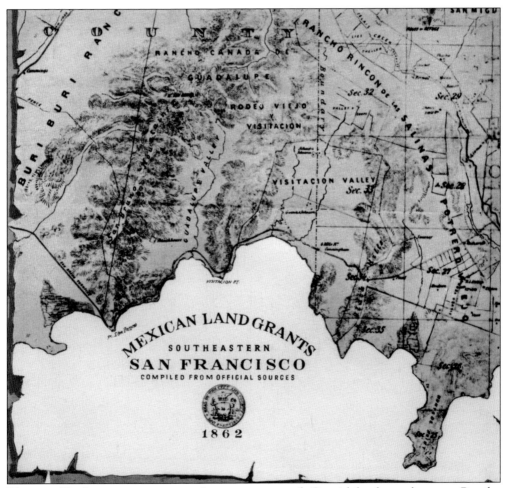

The city of Brisbane occupies an area that was once part of a Spanish land grant known as Rancho Canada de Guadalupe y Rodeo Viejo y Visitacion. This map shows the ranchos in relation to San Bruno Mountain and San Francisco Bay. It also shows the original shoreline of the bay before large areas were filled.

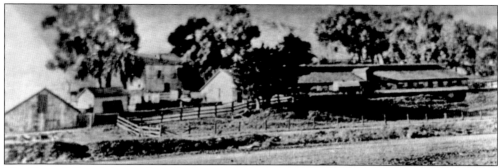

The Kennell Ranch house dated back to 1880. It stood near the tollgate of the old Shell Road and just south of the Seven Mile House (Bayshore Boulevard and Geneva Avenue). Near the Seven Mile House was a blacksmith's shop belonging to the father of Brisbane pioneer Delbert "Bud" Sweet. After rustlers stole cattle from the Guadalupe Ranch, now Crocker Industrial Park, a $2,500 reward poster was nailed to the door of Sweet's shop. It is said Mrs. Kennell collected the reward by tracking the bloodstains of the slaughtered cattle to a butcher shop on Third Street in San Francisco. Fire destroyed the Kennell house and barns on July 8, 1967.

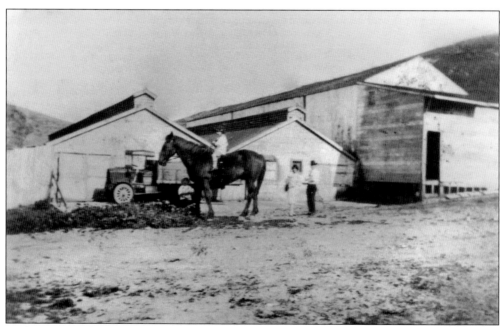

In this c. 1926 photograph of Mozzetti's Dairy, Charles "Bud" Mozzetti sits atop a horse flanked by his parents, Rose and Charles (right), and his brother Clifford beneath the horse's head. The dairy was owned by Ben Mozzetti, a relative of Charles. It stood at the corner of San Bruno Avenue to Lake Street and Glen Park Way, now the site of Firth Park. In the background is a 1922 Fagelo truck.

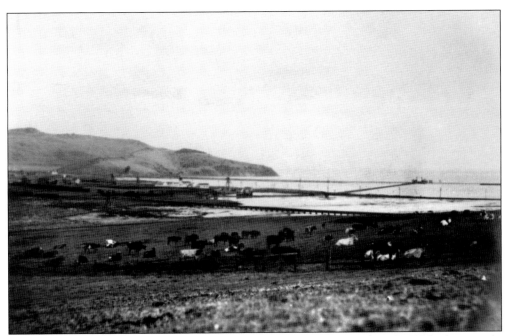

Cows graze peacefully on the lower area of Brisbane in this November 27, 1905, photograph. Candlestick Point can be seen in the distance, and railroad tracks seem to float on top of San Francisco Bay. This was marshy land that was later filled; the area beyond the tracks became the Bayshore Freeway, Highway 101, in the 1950s.

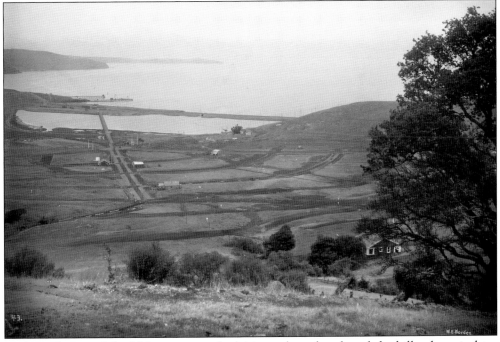

In the early part of the 20th century, only dairies and ranches dotted the hills where, in later decades, houses would be built. (Courtesy of San Francisco History Center, San Francisco Public Library.)

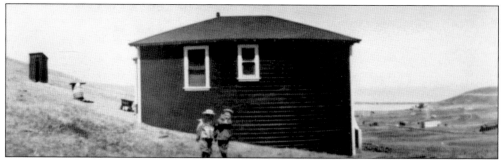

Leo and Lawrence Zeitlmann, early residents, stand in front of their home in 1909. Leo remembered hearing a large male wildcat running over the roof for several nights scaring his mother and brother badly. Using the rifle given to them by their Civil War grandfather, Leo, though scared as well, dispatched the large intruder.

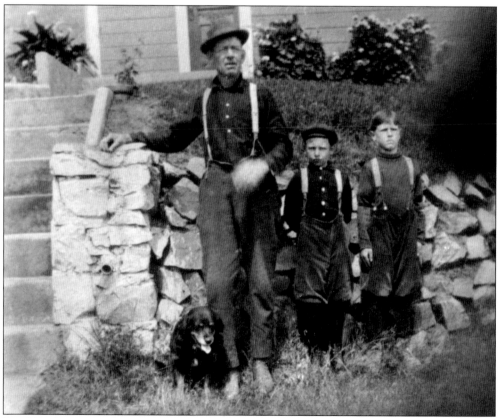

By 1909, there were about nine houses in Brisbane. Herbert Van Deventer built this home and stands by the rock wall at the side of the front entrance with his nephews, Leo and Lawrence Zeitlmann, sons of Herbert's sister, Lena Mary Zeitlmann. The house was built on Lot 15, Block 27 at 240 Sierra Point Road. The rock wall was still standing in 1979.

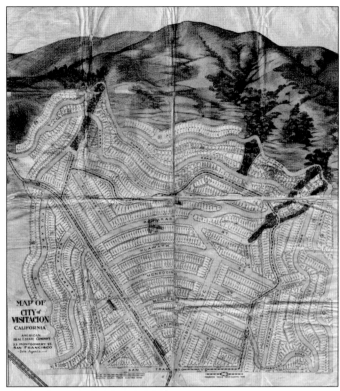

This map, owned by the Allemand family, was produced by the American Realty Company around 1908 to show the proposed layout of Visitacion City complete with streets, lots, and even a streetcar, which was supposed to connect to San Francisco. The project never took off, but the basic design of the streets, which had already been partly established, can be seen in today's layout of Brisbane's streets.

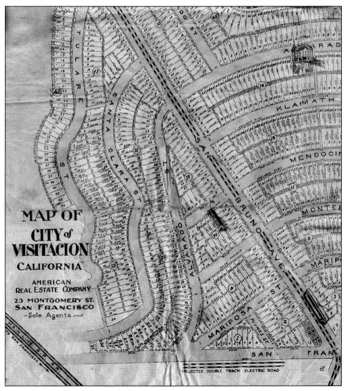

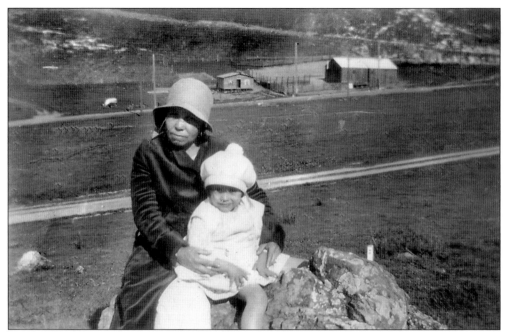

Young Anita Oroquita sits on her mother Lola's lap in 1920. Visible in the background are El Dorado Street and San Bruno Avenue beyond. Note the bare hillsides, now full of homes and apartments.

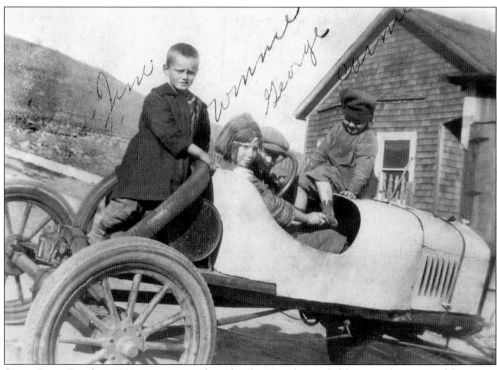

Sierra Point Road in 1921 was a great place for the Naughton children to play in an old car.

In 1929, the Oroquita home at 110 El Dorado Street was the only house in town with a windmill to provide water for the family.

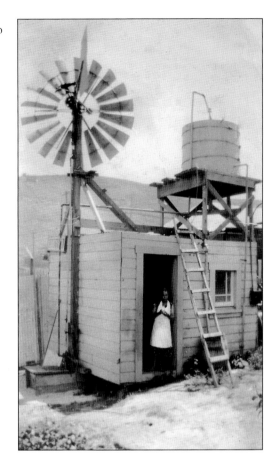

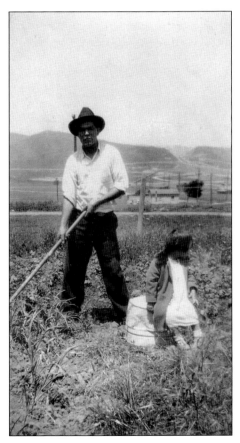

In 1929, the closest grocery store was located in Visitacion Valley. Ralph Oroquita is shown in the vegetable garden he planted at his house at 110 El Dorado Street.

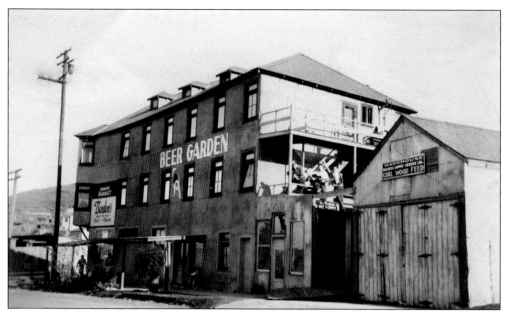

The Allemand Hotel was built in 1909 to provide lodging for potential weekend visitors from San Francisco. This 1937 photograph shows there was a store, Beer Garden, and a shed for coal and supplies. Now an apartment building, this hotel is still home to many Brisbane residents.

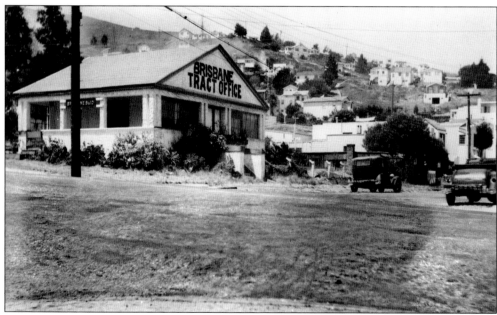

The Tract Office was located at the corner of Visitacion and Mariposa Streets. It was built in 1918 and served those coming to purchase property when Brisbane was laid out as a tract. In 1930, there were some lots selling for $100 with terms of $5 a month. Some were only 100 feet from the sewer and offered electricity with a beautiful view. In the early 1940s, it housed a small 5-and-10¢ store, operated by congenial Oscar and Elsa Von Schoven.

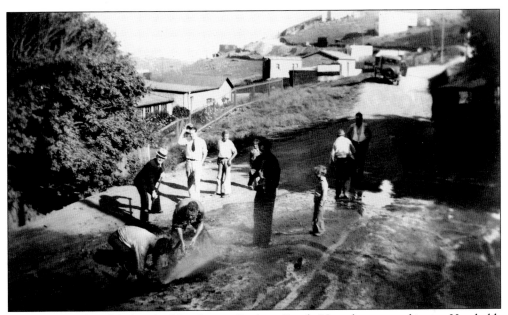

In 1933, men labored daily to build and repair Brisbane Roads. Here they are working on Humboldt Road near Sierra Point Road.

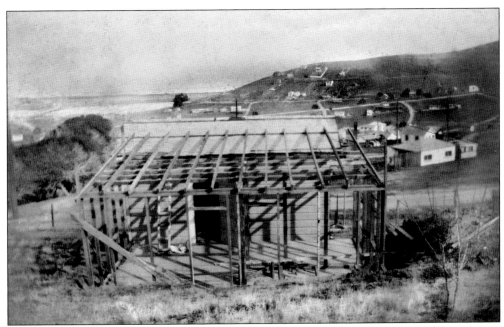

Lots in 1930, during the Great Depression, were reasonable, some selling as low as $50 and some as high as $300. Some early residents saved money by scavenging lumber and materials from the dumps in the Bay Area to build their homes.

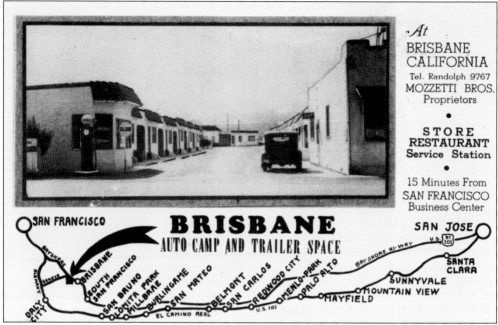

The Brisbane Auto Camp was built in 1929 by Nina and Pep Mozzetti. To promote business, they gave away free lodging but stopped after gypsies ate all their chickens. It was located at the corner of Old County Road and Visitacion Avenue, now the location of Brisbane's Community Park. The motel and trailer park were razed in 1986 in anticipation of the building of a new city hall and community center. When former councilmen Ed Schwenderlauf, Ernie Conway, and John Bell, as well as many citizens of Brisbane, objected to the plans by architect Michael Graves and believed the money could be better spent, the attractive and well-used Community Park was laid out.

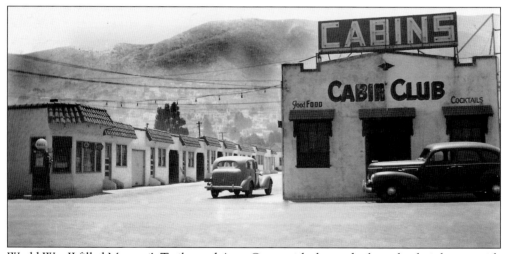

World War II filled Mozzetti's Trailer and Auto Court with those who brought their homes with them. They found work in nearby shipyards. There was a small grocery store and gas pump for residents and travelers. Italian dinners were served at the Cabin Club, which also included a full bar for those who were thirsty.

18

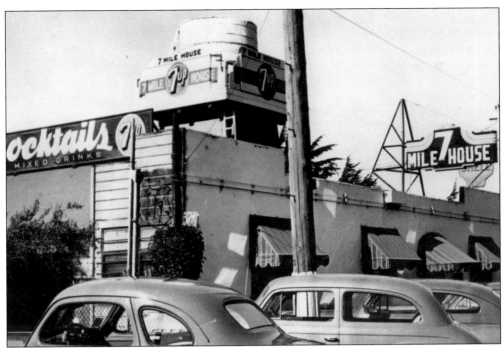

In 1860, a toll road was built from San Bruno to the San Francisco County line. There stood the tollgate and the Seven Mile House, once a hotel. Toll road travelers, famous banker William Ralston, and milkers from Brisbane's dairy farms stopped at the Seven Mile House to eat, drink, rest, and water their horses. The present bar was converted from a beer parlor, once adjoining the hotel. The back bar is the original. The Seven Mile House is Brisbane's oldest historical landmark. This photograph is from 1949.

Helen and Al Pearson, a hod carrier, added another room to their house whenever enough material was acquired from Al's jobs in the early 1930s. When he got a window, a hole was cut for it, or the room stayed dark. From left to right are Jack Blanchard, Francis Mays, unidentified, and Helen Pearson. Note how homes were beginning to dot the hillsides of Brisbane.

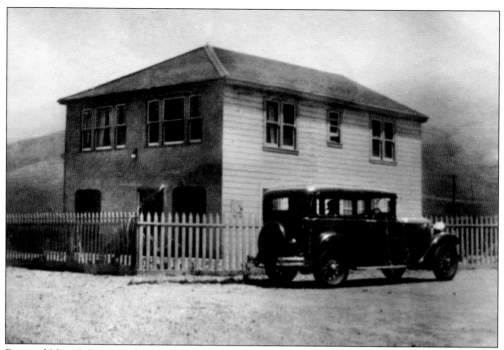

Pep and Nina Mozzetti offered the basement of their home in the auto court as a school until a house at 238 Alvarado Street was opened as Brisbane's first school. Maude Prestedge served as PTA president.

The address of the Brisbane School in the early 1930s was 283 Alvarado Street. The rent was $25 a month. This photograph came from a time capsule opened in June 1986 by early pioneers who had attended the first school. Used for the last time on June 8, 1936, the Alvarado Street school was replaced by a new school on El Dorado Street and Glen Park Way.

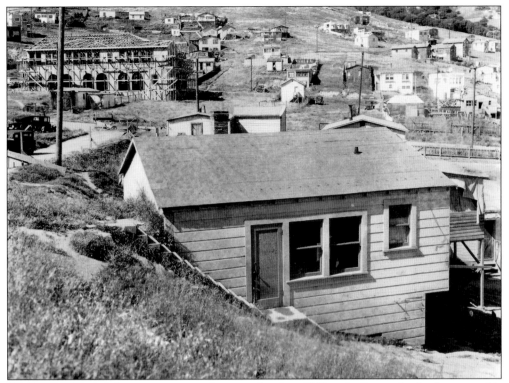

Brisbane welcomed the construction of a new school on El Dorado Street. In the foreground is the stark building used from 1930 to 1936. It was located in the rear of 283 Alvarado Street and cost $10 a month to rent in addition to the rent for the Alvarado Street building. On the board of trustees were Ethel Jonas, Jessie Ford, and clerk Jack Wheeler.

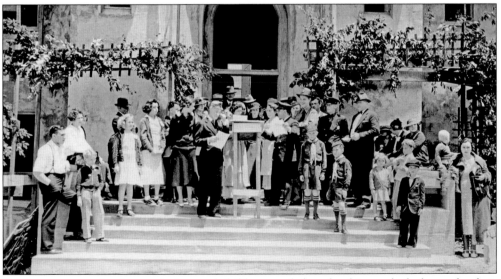

Brisbane was growing in population, and children needed a school instead of a house for their classroom. A crowd gathered to welcome the dedication of a Brisbane Elementary School. The band played under a decorated flower arbor; Scouts, volunteer firemen, school board members, and dignitaries welcomed this day, June 7, 1936.

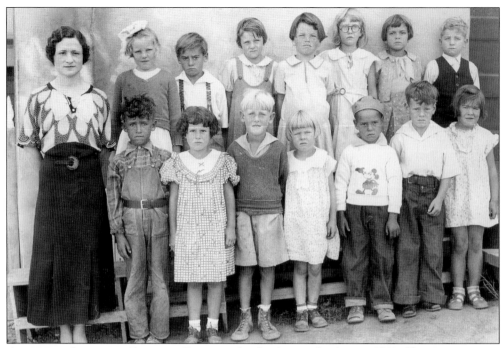

A young and energetic Ernestine Storti taught the first-grade class in 1932. She was generous, bringing apples, oranges, pencils, and paper to Brisbane children. Raised in Redwood City, Ernestine Storti Hollbrook spent 34 years of teaching before retiring.

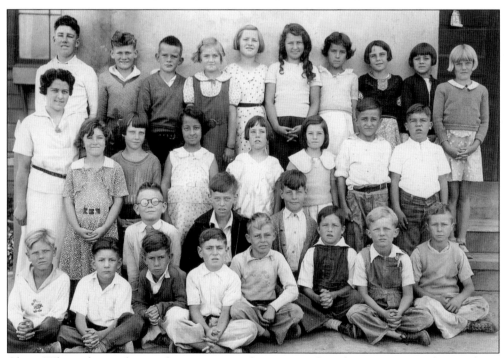

Claire White, the teacher in this 1932–1933 class picture, later became principal at Brisbane Elementary School. In 1932, there were a total of 44 students in the Brisbane school.

A trip to the San Francisco Zoo in 1933 was a special treat for Brisbane Elementary School children. All dressed up for the field trip from left to right are the first three teachers of Brisbane students, Claire Bouret White, Natalie Lipman, and Ernestine Storti Holbrook.

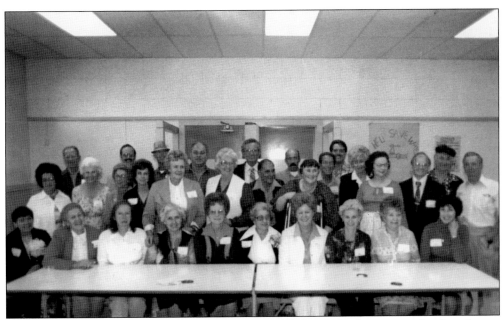

Students of Claire Bouret White hosted a reunion filled with fond memories for their former teacher at the Brisbane Elementary School on October 18, 1980. White was their teacher in the 1930s at the old school on 283 Alvarado Street. The bell used to call children from recess was given to the Brisbane History Collection by White.

Getting ready for the Fourth of July parade in 1939 are, from left to right, (front row) Richard Blanchard and Larry Jenkins; (back row) Shirley Schwenderlauf, Larry Blanchard, and Barbara Schwenderlauf.

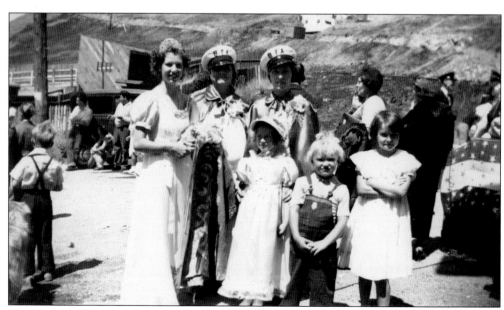

The Fourth of July was always reserved by Brisbane's population as a parade day. Queen Violet Blanchard and her court are prepared for the start of the parade in 1935. This picture was taken close to the firehouse, built by volunteers, on San Bruno Avenue and Glen Park Way.

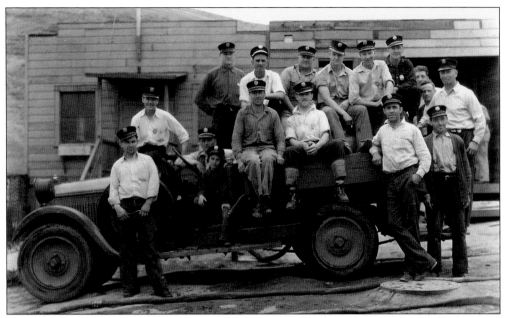

Brisbane volunteer firefighters fought many destructive grass fires in early Brisbane. Shown in front of the Brisbane School at 238 Alvarado Street are volunteers with their homemade fire apparatus before they had uniforms. The building on the right was their Social Hall, which was being built by the firemen themselves. Lou Terry is in the driver's seat with his daughter Louise, the mascot of these 1933 volunteers.

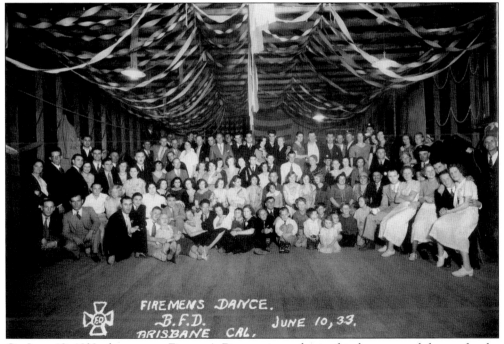

On June 10, 1933, there was a Fireman's Dance: ties and suits for the men and dresses for the ladies. Children joined in the fun social event, too. This was held at their social club hall, which is now the Our Lady of Guadalupe Catholic Mission Church at 285 Alvarado Street.

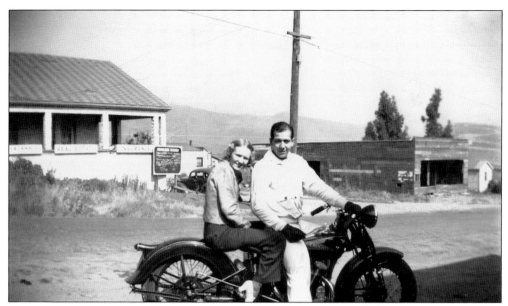

The year was 1938 when construction of 50 Visitacion Avenue (at right) began, which became a pool hall, bar, and card room. Also shown in the background is the Brisbane Tract office. Members of Brisbane's Motorcycle Club rode the open spaces available to them.

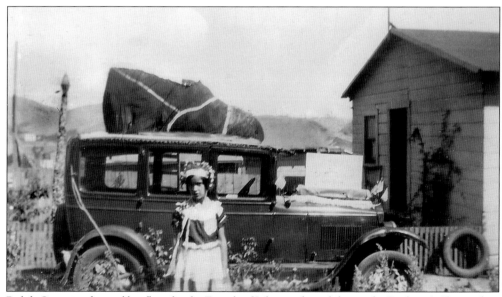

Ralph Oroquita donned his float for the Fourth of July parade with his trade: Brisbane's Shoemaker. Decorated in crepe paper, too, was daughter Anita's dress.

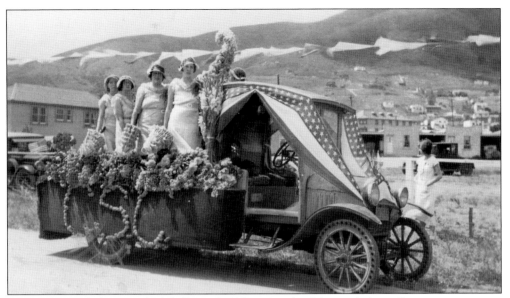

This is the Catholic Social Club float of 1935, pictured at Mozzetti's Auto Court property, now the Community Park. Motel cabins and the Mozzetti home are in the background. The first two women on the float are Margaret Schmidt (far left) and Maud Pergeaux. The decorated truck is facing Old County Road.

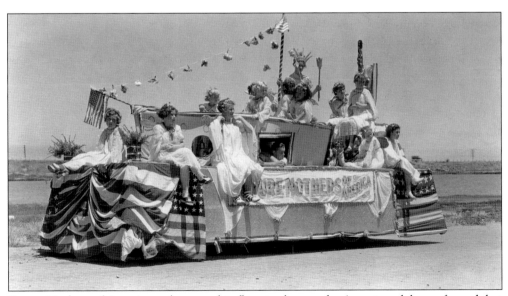

Future Mothers of America rode upon this float in the parade. A sewing club was formed, but they also enjoyed gathering to chat and eat in 1935. Myrtle Booth was their leader.

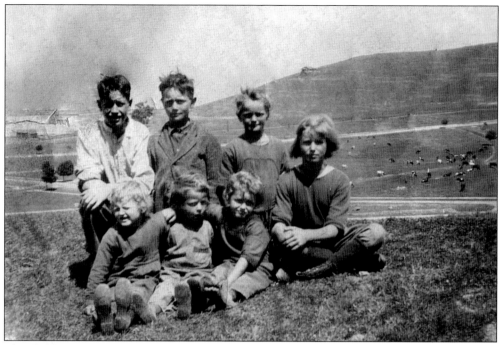

The children of John and Elizabeth Naughton enjoyed the spacious roaming areas in 1921. Bob, George, Jim, Ed, John, Winnie, and Carmel sit for a photograph on Sierra Point Road, while cows roam the dirt streets.

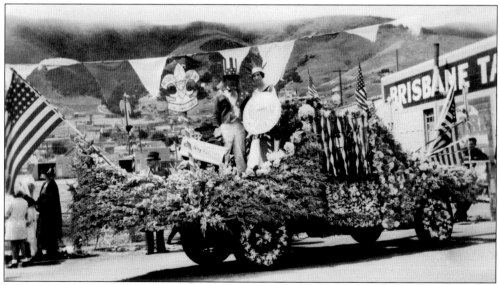

Well decorated with flowers, this 1935 float is turning into Mozzetti's Trailer and Auto Court for the barbeque after the parade. The passengers may have been thirsty and stopped first for a glass of beer or wine at the Brisbane Tavern at Visitacion Avenue and Old County Road.

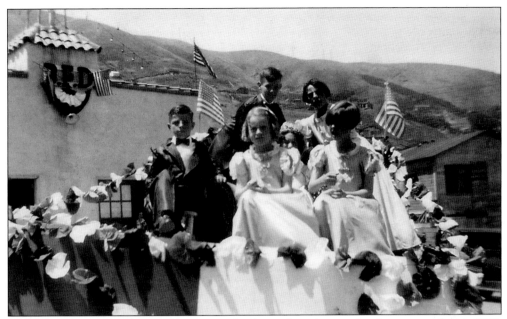

Paul Schmidt was one of the children excited to be on the volunteer fire department float in 1929. The parades were a great time for children and adults to enjoy a festive day. Parades began at Glen Park Way and San Bruno Avenue. Plans for the firehouse were drawn by Felix Schwenderlauf and built by the Brisbane Volunteer Fire Department.

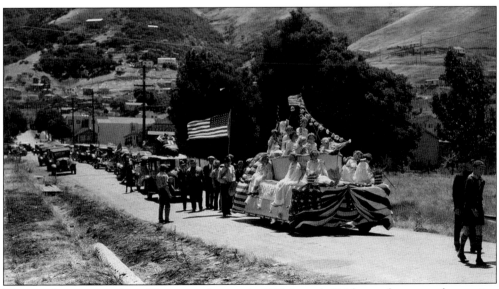

The parade is coming down Visitacion Avenue in 1935. In early Brisbane, there were few to view the floats and marchers because most of the town was in the parade.

In June 1960, in a decorated car, are newlyweds Mansel and Marion Roland going up Visitacion Avenue. The building shown, 402 Visitacion Avenue, was built around 1938 by John and Mame Fourney. John opened a radio shop and then a hardware store. Later the building housed Dr. Fred Lawrence, Bill Harris's television repair, and Rudolph's Beauty Shop. Today popular Madhouse Coffee is well visited by residents.

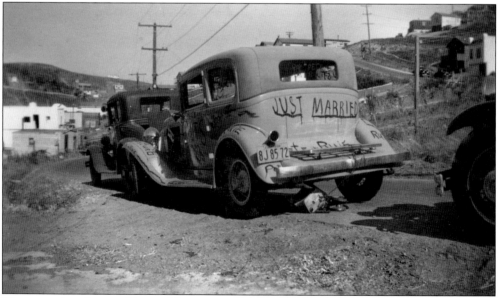

There was time for a wedding celebration, with a decorated automobile in 1935, for Pierre Sarey and Ruie Coffin.

Snow does occasionally fall in the Bay Area, touching the tops of such elevations as Mount Tamalpais at 2,571 feet, Mount Diablo at 3,849 feet, and San Bruno Mountain at 1,314 feet. San Bruno Avenue crosses horizontally in the foreground with a fresh snowfall touching much of San Bruno Mountain in the background. In this 1927 view, Brisbane has unpaved streets and a sparse collection of houses.

Around 1930, there are a few homes on the slopes of San Bruno Mountain and a few cars on Visitacion Avenue. At left is a café adjoining Mozzetti's Auto Court and Trailer Park. In the foreground is the covered Hetch Hetchy pipe that brought water to Brisbane residents.

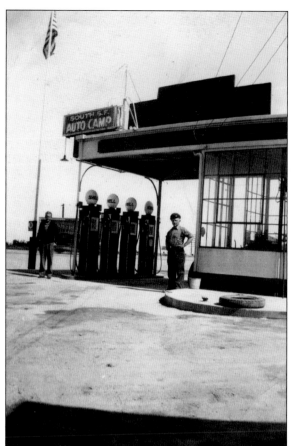

Mozzetti's gas station moved from the auto court to facing Old Bayshore Highway in April 1939. In 1935, gas was 17¢ a gallon. Charles Mozzetti, standing in the picture, was the brother of Pep Mozzetti, who ran the auto court, and Dico Mozzetti, who operated Brisbane Inn. The brothers—Charlie, Pep, Pete, and Dico—emigrated around 1928 from Locarno, Switzerland.

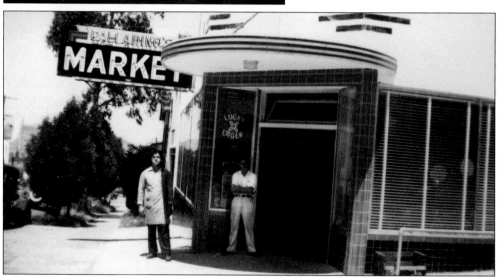

Brothers Joe, Henry, and John opened Pallidino Brothers Market at 185 Visitacion Avenue. In 1940, the population was increasing, and there was a great need for a larger market. Many did not have automobiles to shop elsewhere. During World War II, gas rationing also helped the market flourish.

Brisbane Market offered two artichokes for a nickel and 4 pounds of asparagus for a quarter, and Challenge butter was 33¢ a pound. Store owner "Butch" Mudersbach stands at right with his Brisbane employees in front of the store.

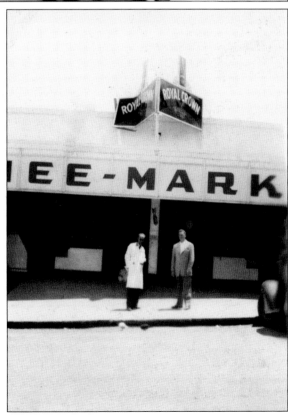

Located at 249 Visitacion Avenue, Thee Market was constructed and opened in 1940. Owners of this unique open-aired market with sliding doors were John Hogerheiden and Walter Blythe. Due to wind and dust, the building was enclosed with front doors about 1942. Taking a challenge to open a "supermarket" store in a small town, John and Walter did very well, thanks to the wonderful people of Brisbane.

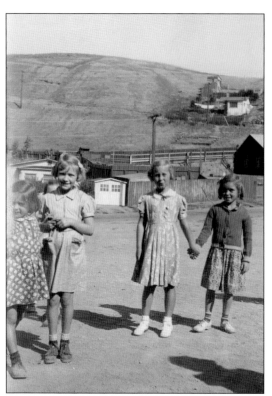

Holding hands in this 1937 photograph during recess are Jeannie Heinzer and Helen Richards (right). Second to the left is Lois Heinzer in the Brisbane Elementary School yard.

In the late 1930s, Santa Clara Street was still a dirt road with a few homes. Thelma (mother), Larry, and Juanita Blanchard pose for this picture. Thelma's husband, Barney, was a Brisbane volunteer fireman.

34

Two

STARS SHINE IN BRISBANE

Brisbane is known as the City of Stars, not only for the stars that dot the hillside and shine out during the winter holidays, but also for the many wonderful people who have graced this town. The first stars, of course, were the Ohlone people. This photograph shows what is believed to be one of the last Ohlone at the dawn of the 20th century.

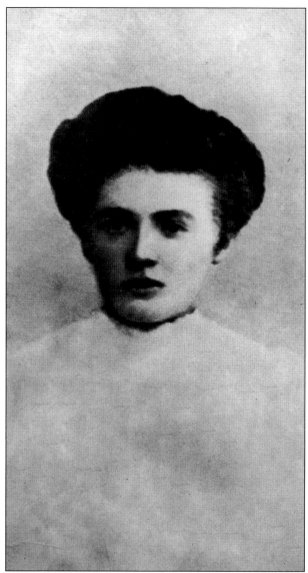

Tillie Moranda, born in 1892, immigrated to the United States in 1913 and married Steve Mozzetti. Steve was a partner in Mozzetti's Dairy, located on Glen Park Way. With their infant daughter Lena, they moved to Brisbane in 1916. There were about four families living in town: the Sweets, the Naughtons, the Allemands, and the Lindes. Lots were $50. Tillie cooked for 18 dairy hands and tended to her family with no electricity; water was delivered in containers and wood had to be chopped for the stove. The ranch house was nestled among trees, now the site of Firth Park; the bunkhouse was at the corner of Glen Park Way and Ross Way. Tillie tended to a garden, raised chickens and turkeys, and gathered eggs quickly as the Swiss dairymen enjoyed sucking the contents right from the shell. Wash was hung at night to avoid roaming horses and cows. Singing, lanterns in hand, the dairymen went to early chores. Liquids other than milk came from the dairy. A still was constructed by the Swiss for their enjoyment. Hay for 150 cows came from a wharf facing Brisbane. With heavy winter mud, the dairy hands would have to push the truck up the hill to the barn. Young Tillie loved Brisbane. She worked hard and had her family and said it was the best time of her life. Tillie was into her 80s when she passed away in December 1983.

Married in 1922 to Joe "Pep" Mozzetti, Nina Petrini, along with Charles Mozzetti, worked hard to build and promote the first auto and trailer court in this area. In 1929, the San Francisco Bay came almost to the front of the auto court. Free space was offered, but gypsies were asked to leave when the Mozzetti chickens began to disappear. The highway ran past their house and gas pump. The gas pump was moved, and a service station was established on Bayshore Boulevard in 1926.

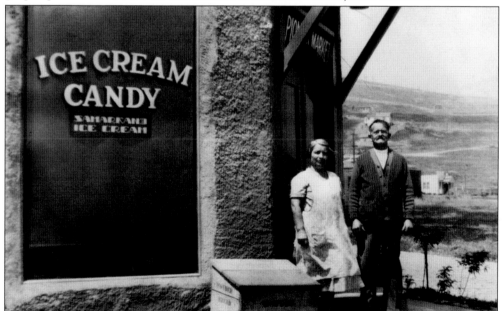

Brisbane pioneers Julie and Elie Allemand, emigrants from France, met and married after arriving in the United States. They settled in Brisbane in 1908 and had two sons, Emile and Leo. Their market was located on the ground floor of the Allemand Hotel at 100 San Bruno Avenue. The first post office was housed in this building. During World War II, the navy leased the hotel for navy housing. Elie Allemand died in 1956, and Julie followed in 1975.

Young Charles "Bud" Mozzetti sits proudly on a horse at the site of the Mozzetti Dairy in 1926. The Mozzettis were Italian Swiss, as were the milkers at the dairy.

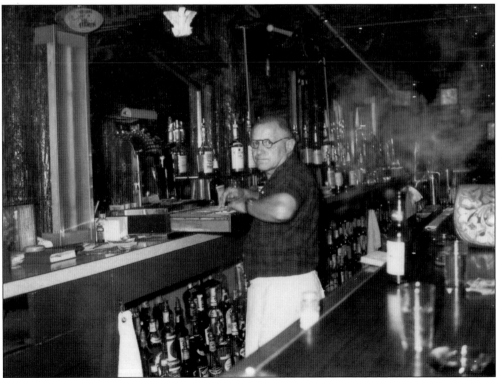

In the popular Brisbane Inn, a busy Dico Mozzetti tends to customers in 1950. Dico and his wife, Lena, were members of early pioneer families.

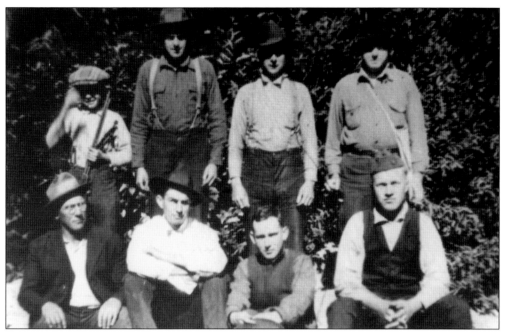

Delbert "Bud" Sweet came to Brisbane in 1914 with his family. His father, at far left, owned a blacksmith shop in Brisbane. The Sweet family got water from springs on Klamath Street, San Bruno Avenue, and San Benito Road. Some said water flowing into ponds was mash-flavored and that cows gave well-spiked milk because of bootleggers in the hills.

In the 1970s, Delbert "Bud" Sweet came to the Brisbane Library to reminisce about his years in Brisbane in the early part of the 20th century. His family raised ducks and geese, money was hard to come by, and youngsters provided their own recreation, such as rowing a flat-bottom boat on the big pond that fronted the town in the 1920s. At high tide, the water came up to where Crocker Industrial Park and the Community Park are now.

John Gomez had the job of delivering newspapers to Brisbane homes in a horse and buggy driven by Mrs. D. Halliday. He was paid 2¢ a day. In 1933, 2¢ could buy a lot of candy for John. Mrs. Halliday lived on San Francisco Street, and her old white mare was stabled nearby at the northeastern corner of San Francisco Street and Visitacion Avenue. It was necessary to use a horse and buggy as houses were so scattered along unpaved roads that were muddy in winter in Brisbane in the early 1930s.

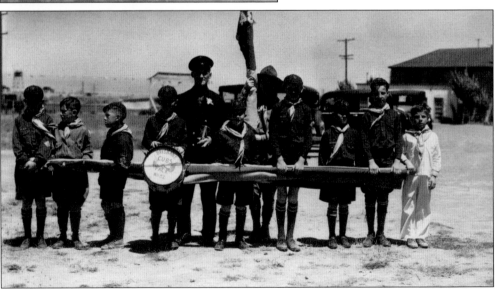

The Fourth of July Parade in 1935 always included the Cub Scouts. Waiting for the parade to begin, Felix Schwenderlauf proudly poses with the group at Mozzetti's Trailer and Auto Court. In the background are the Mozzetti home and the washhouse for tenants. Felix's son Eddie (fourth from the right) became one of Brisbane's first city councilmen in 1961.

This is Brisbane's first Girl Scout troop on March 15, 1933. From left to right are (first row) Alice Van Zandt, Bernice Hillingum, and Ellen Lind; (second row) Elaine Frederick, Phylis Hillingum, Ruby Netzer, Eleanor Frederick, and Clara Van Zandt; (third row) Emma Frederick, Aunt Ollie Baylor, "Bluebird" King, two unidentified, and Dorothy Miller Radoff. King, the Scout leader, founded the troop in 1932.

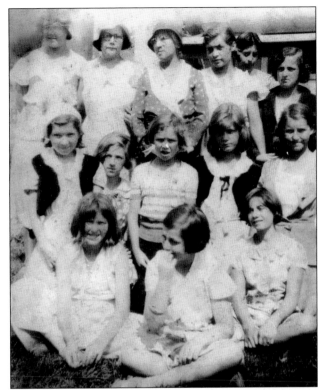

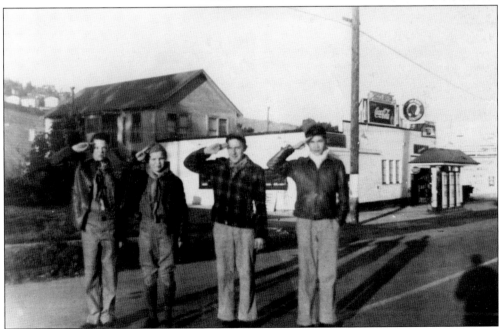

Saluting on San Bruno Avenue in 1948, from left to right, are Brisbane Boy Scouts Bob Tann, unidentified, Robert High, and Norman Brown. In the background is Chuck's Mohawk Gas Station at 22 San Bruno Avenue. Chuck and his family ran this full-service station, pumping gas and repairing automobiles. A private residence was in the rear of the station.

In 1978, Mr. and Mrs. Leo Zeitlmann visit the library at 245 Visitacion Avenue to tell Mayor Don Bradshaw (left) about the early days of Brisbane. Leo was a small child when his family lived here until 1919 at 240 Sierra Point Road in a house built by his uncle, Herbert Van Derventer. In 1909, there were about nine houses in Brisbane. Residents picked up their mail from boxes in Visitacion Valley, bought vegetables at the Seven Mile House (at the corner of Old Bayshore and Geneva Avenue), and bought groceries in Visitacion Valley or on Third Street in San Francisco. Bakery goods were purchased from a wagon that came into Brisbane weekly.

Mary Richards Arcotti celebrated her 91st birthday with many old friends at the 23 Club. Mary was a native of Germany and married World War I soldier Curtis Richards. The couple purchased property in 1929 and built their home in Brisbane in 1931, raising four children: Curtis, Raymond, Rudy, and Helen. Mary was active with the PTA and the Women's Legion Auxiliary and for many years cooked for the Brisbane Elementary School. She was also a strong advocate for child welfare. Former students have fond memories of Mary's tasty school lunches. In 1948, she married Emil Arcotti, and they spent many happy years together. Mary stayed active with the Brisbane Seniors, going on trips until her death in 2000.

Visiting Brisbane relatives in 1929, Felix Schwenderlauf discovered reasonable lots. In 1933, Felix, his wife, Lillian, daughters Barbara and Shirley, and son Eddie moved into a house on El Dorado Street, constructed by Felix. Joining the volunteer firemen, Felix drew plans for a firehouse, which was then constructed by dedicated and hardworking volunteers. Dances were held to pay for materials and became a regular social event. Felix became a scoutmaster, taking boys on camping trips. In 1943, Felix and his son, Ed, joined the navy, both serving until the war's end. Felix retired and died in 1976 in Oakdale, ironically the same town from which Brisbane's first fire truck was ordered.

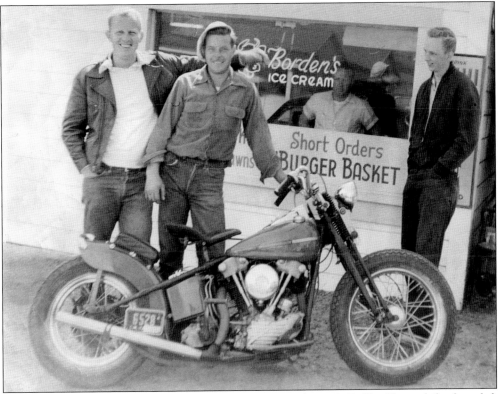

Jean Fogleman peeks from his 19 Visitacion Avenue Fogleman's Coffee Shop while, from left to right, Ed Schwenderlauf, Carl Collar, and Eddie Brenzel admire Carl's motorcycle in this 1950 photograph. Schwenderlauf grew up, raised his family in Brisbane, and was very vocal for incorporation, becoming one of Brisbane's first councilmen. He served on the council from 1966 to 1967 and became a strong advocate fighting for the Community Park instead of a city hall on Old County Road. During World War II, Carl Collar served with the Merchant Marines, married Anita Oroquita, and raised his family in Brisbane. Eddie Brenzel was also raised and lived in Brisbane with his parents and sisters, Madge and Barbara.

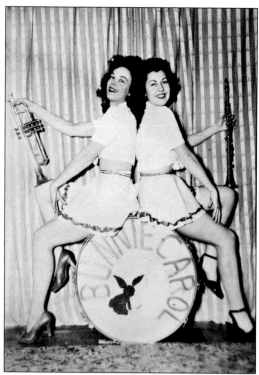

The Bunnie Carroll Studio, at 243 San Benito Road, was a popular magnet for Brisbane youngsters taking music and dancing lessons from the early 1940s. Vincetta Turtureci (right), who played the saxophone at the USO Club during World War II, poses with Bunnie in 1942 in preparation for a show. Vincetta moved to Brisbane when she was three with her mom, Edith Lewis Roeder, in 1930. Vincetta married Jess Salmon, one of Brisbane's first councilmen.

A ball field on the side of the old Brisbane entrance was heavily used by boys and their games. Pictured here from left to right, Dick Firth, Larry Blanchard, and Rich Trantham played with the Brisbane Athletic Club until they were teens.

Another of Brisbane's first councilmen, Jess Salmon, serving from 1961 to 1973, came to Brisbane from Oklahoma and served in World War II. Jess married the girl selling tickets at the Brisbane Theater, Vincetta Turtureci, and raised their children—Linda, Laura, Marc, and Michele—in Brisbane.

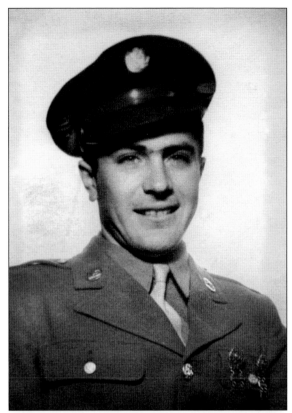

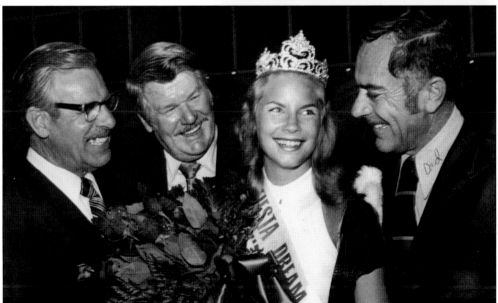

Seen here from left to right, Bill Lawrence, former councilman; Jim "Red" Williams, one of Brisbane's first councilmen from 1961 to 1965; and Jess Salmon congratulate Paula Schmidt. Paula won the Miss Brisbane contest and went on to San Mateo County to take the title of Miss Fiesta Dream Girl in 1973.

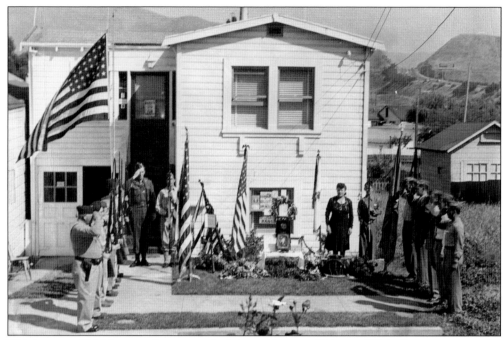

This house at 134 Monterey Street was the home of Vera and Linwood Blair. For many years, the memory of their son, Walter, was celebrated on Memorial Day. Walter, the only child of the Blairs, was lost during World War II. The American Legion Walter Blair Post No. 467, Boy Scouts, and the Blair's Rangers show their respects on Memorial Day in this 1950 photograph.

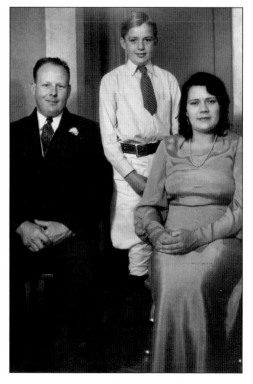

Linwood "Sarge" Blair and his wife, Vera, a Russian war bride of World War I, came to Brisbane during the early 1920s. Their son, Walter, born soon after, was their pride and joy. A handsome man, he joined the army and was lost in 1943. "Sarge" created the unique group Blair's Rangers in June 1942, composed of 38 boys and girls, and eventually trained hundreds as soldiers in the infantry. Twice a month, Sarge took boys, wearing helmets and loaded with full pack, on an overnight bivouac. Hiking for 2 miles, they attracted motorists along the highway close to Brisbane where they camped in a grove of eucalyptus trees. Blair taught classes for the boys in basic service and taught them to be proud of their country. Years later, many young men wrote letters from Korea and Vietnam explaining how being a Blair's Ranger and Sarge's training helped to save their lives. After Sarge's death in February 1956, Vera continued with her work at American Legion Walter Blair Post No. 467 at 250 Visitacion Avenue. Vera passed away in September 1970, leaving a void in town and at the Walter Blair Post No. 467.

First Lt. Walter A. Blair was stationed with the 8th Air Force in England. He was lost near Frankfurt, Germany, in October 1943. He was listed as missing in action and presumed dead as of August 1945 at the young age of 20.

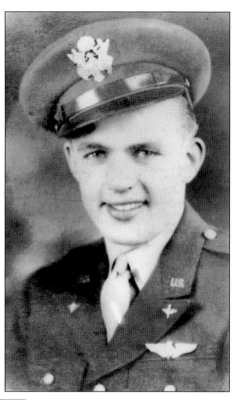

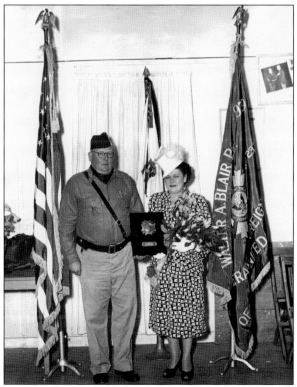

A proud yet somber Sarge and Vera Blair accept a plaque in honor of their son, Walter, a bombardier lost in action during World War II over Germany. The American Legion Hall at 250 Visitacion Avenue was dedicated to the memory of their son. Sarge died in February 1956. Vera stayed active with the American Legion in Brisbane until her death in September 1970.

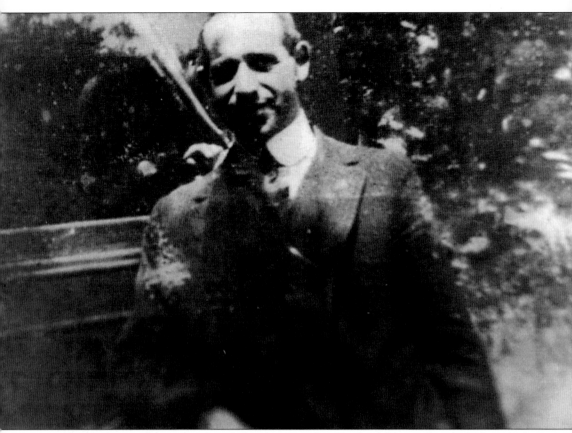

Arthur Annis was born into a Jewish family in London, England. His mother died when Arthur was a child; his father remarried several times and the stepmothers decided they did not want to care for Arthur but did want his sister. He was sent to an orphanage, from which he escaped at the age of 14 and joined the Merchant Marines. By the time he was 17, he was an overseer in a diamond mine in South Africa. He came to the United States sometime before the 1906 earthquake and took up residence on Cabrillo Street in San Francisco. Annis came to Brisbane in 1929 to reopen the Tract House after real estate developers failed to attract very many buyers for their Visitacion City tracts in the years before and after World War I. He was the agent to sell lots owned by a man named Margolis in Brisbane. People remember him as a generous man bringing fruit and gifts to Brisbane children at Christmas. Annis changed the name of the town from Visitacion City to Brisbane to differentiate it from the nearby Visitacion Valley district in San Francisco. Streets in Brisbane reflect the names of Annis's children, Joy, Harold, and Gladys, as well as possibly Margolis's son and daughter-in-law, Paul and Margaret. Daughter Joy remembers coming to Brisbane to rent Shetland ponies from Mozzetti's farm. She took tap dancing lessons from Gracie Allen's sister in San Francisco and remembered Frank "Bring em back alive" Buck, who lived close by. When Joy was 12, Arthur Annis died of peritonitis of a burst appendix. (Courtesy of Joy Hillman Annis.)

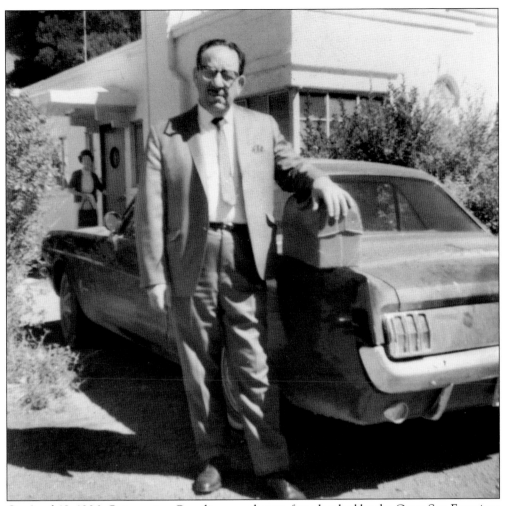

On April 18, 1906, Guisseppina Guardino was thrown from her bed by the Great San Francisco earthquake. Five months later, the third of her eight children, Salvatore Joseph was born. After graduating from St. Ignatius High School in San Francisco, he attended San Francisco Polyclinic (today an extension of the University of California, San Francisco) for pre-med studies and then graduated from Creighton University in Omaha, Nebraska, in 1930. He and his new wife, Clotilde Buratti, both worked to pay his way through medical school, Salvatore by boxing professionally. In 1936, he opened his first office in Brisbane at 360 Mendocino Street, where he and Clotilde lived in an attached apartment. Patients who could not pay cash paid in chickens and eggs. Later, because of financial concerns, Dr. Guardino joined the Civilian Conservation Corps as a camp doctor. He returned to Brisbane in 1938 until he was drafted in 1941 and served in the Aleutian Islands. At the end of World War II, he returned to his Brisbane office. He was an old-fashioned doctor in the best sense of the term; he would always answer a call and often provided free medical service and prescriptions and made house calls. By 1968, he had built a new home at 301 Harold Road and had won a seat on Brisbane's City Council in a landslide. Showing the passion of a man who had been a boxer in his youth, he plunged into the city's most controversial issues, often showing up on television's nightly news. In 1972, he established the Teen Center at 250 Visitacion Avenue as a place where teens could join activities away from alcohol and drugs. Dr. Guardino had two daughters, Elissa, from his first marriage, and Stephanie from his second to Connie Edwards. He died in 1975 after many years of devoted service to Brisbane residents.

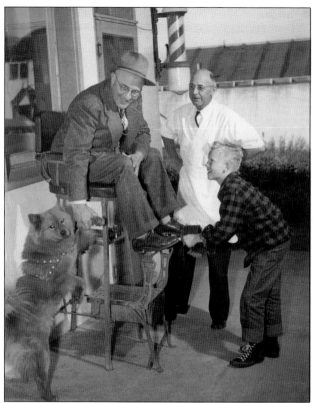

Richard Trantham shines the shoes of William Marquette in the chair as barber Harry Hardesty looks on. Queenie the dog shares the picture. The small barbershop was on the right side of the Brisbane Theater. A realtor, Marquette and his wife, Martha, had an office on the other side of the theater at 44 Visitacion Avenue. Richard was raised in Brisbane and was an active member of the Brisbane Athletic Club.

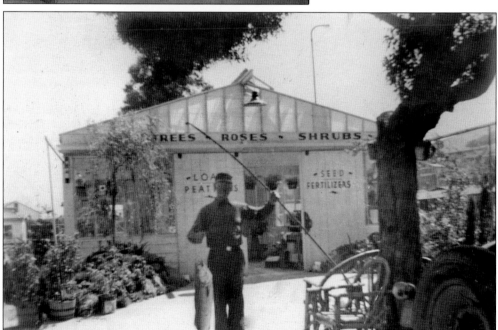

Adolph Grabovsky's complete nursery was located at 23 San Bruno Avenue from 1930 through 1940. Here Adolph shows off a fish he caught in the bay in front of Brisbane. His son Jack was an active and popular scoutmaster.

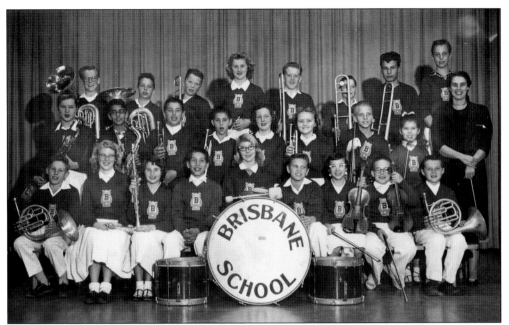

Being in the Lipman School Band inspired many to continue on to greater heights and teach music. This 1958 photograph taken by Ralph Paradise shows students in uniform with their instruments. From left to right are (first row) Mike Muzio, Barbara Spencer, Linda Andrews, two unidentified, Donald Kasper, and three unidentified; (second row) Pat Brazil, Frank DeMarco, John Deher, Paul Schroeder, Sandy Gylfe, Shirley Plank, Don Dahlstrom, Barbara Kerling, and director Diane Egli; (third row) Scotty Turner, Rocky McLain, Brian Thompson, Penny Richner, two unidentified, ? Rivera, and unidentified.

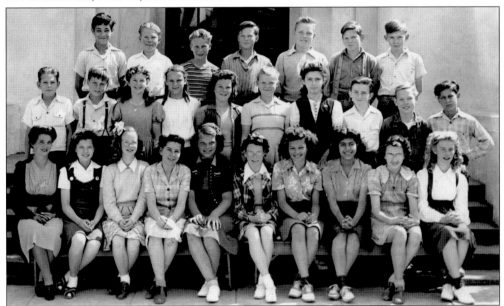

The seventh-grade teacher, Miss Colclough, sits on the steps (first row, far left) of the Brisbane Elementary School with her class in 1942. World War II taught kids how to save aluminum, buy U.S. Saving Stamps, learn songs of the armed services, and darken the house when air raid sirens wailed.

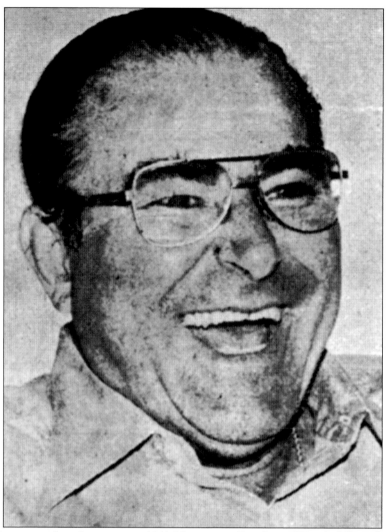

John DeMarco came from Louisiana in 1941. His parents, Rosalie and Frank, followed, along with his sisters Vita, Sara, Mary, and brothers Frank, Tony, and Joe. Some went to work in the World War II shipyards, and John bought the 23 Club from a couple known as "Pete and Pearl." During World War II, servicemen packed the place on weekends and danced to swing, the dance of the era. Johnny married longtime resident Lillian Linde and raised Diane, John, and Vita, known as "Nugget." Soon the popular 23 Club was serving delicious dinners with music every Friday, Saturday, and Sunday evenings. DeMarco hosted special parties, chamber of commerce events, dinners, and celebrations. Mainly, the 23 Club became a well-known mecca for "weekend cowboys" and for Country and Western entertainers such as Johnny Cash, Buck Owens, and Ernest Tubbs among many others who became famous. In 1959, Jerry Lee Lewis thrilled local onlookers and many from out of town with his booming piano antics. DeMarco also became famous for his buffalo feed, where four whole buffalos were cooked on a special rotisserie for almost 25 hours in 1974 with thousands attending. The buffalo barbeque is documented in the *Guinness Book of World Records*, which DeMarco proudly displayed along with his huge grin. For some years, there were luncheons where lingerie was modeled, and they were well attended by workers from nearby offices. Brisbane lost its gregarious John DeMarco on July 17, 1975, to leukemia. Many agreed they did not think he could be replaced.

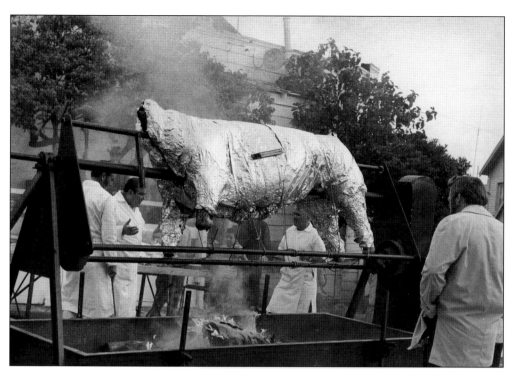

In September 1974, DeMarco's Buffalo Barbeque entered the *Guinness Book of World Records*. Four buffalos were turned on an enormous rotisserie, wrapped in stainless steel mesh blankets that helped ensure even cooking and controlled meat shrinkage. Here DeMarco watches over the rotisserie and enjoys his success at winning a place in the *Guinness Book*. (Courtesy of Harry P. Costa.)

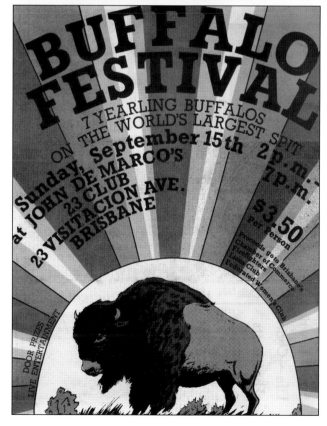

This colorful advertisement promoted the unique event. Besides tasty buffalo, there was lively dancing until late in the evening.

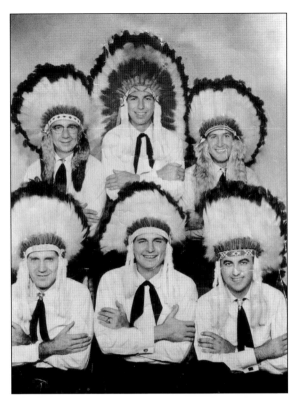

The 23 Club had many entertainers who became famous. Among them were Johnny Cash, Buck Owens, Ernest Tubbs, Marty Robbins, and the Cherokees. During the war years, the place was packed with servicemen enjoying the evening before they left for overseas. Later lovers of Country and Western music flocked to dance and enjoy themselves at the 23 Club. Jimmy Rivers's group, the Cherokees, shown here around 1950 with their beautiful headdresses, was a favorite. Pictured from left to right are (first row) Chuck Wright, Rocky Arnold, and Bob Onstadt; (second row) unidentified, Jimmy Rivers, and Roy Hearn.

The 23 Club was a top Country and Western spot in the Bay Area from the 1950s through the 1970s. Jimmy Rivers and the Cherokees packed the place from 1961 to 1964 with their unique western swing and jazz. "Brisbane Bop," their recording done at the 23 Club on Visitacion Avenue, has always been popular. In 1961, on New Year's Eve, Jimmy Rivers, while flagging down automobiles because of a stalled car, was forced to jump into San Francisco Bay to avoid being hit on the San Mateo Bridge. He was saved and made it in time to play at the 23 Club, much to the delight of John DeMarco and the waiting crowd.

Servicemen came home after World War II, grateful to be back where they grew up and to be with their families. Richard Blanchard was one, seen here across from the Brisbane Theater on Visitacion Avenue about 1946.

Bernice Lummus moved to Brisbane in 1929. At that time, her folks built the only house on the block at 432 Mariposa Street. Attending school with only 15 children, Bernice would run home because she was frightened of the chickens, geese, and cows that roamed the dirt streets of Brisbane. By 1931, there were 44 students; those in the fifth grade and above were sent to South San Francisco grammar school. Bernice married Jack Blanchard in the 1940s, and they raised daughters Joann and Jackie in Brisbane. Bernice died in 1990, and Jack followed in 2003.

These two gals, Juanita Blanchard (right) and Vickie Rae, are out on the town and ready to go to the Brisbane Theater, which was usually packed for double-feature movies. In 1954, folks dressed up, skirts were long, and it cost 50¢ to go to the movies.

Many Brisbane residents have shown a great variety of talents over the years. In 1958, the town proudly presented *The Curse of the Aching Heart*, a stunning melodrama by this group of lovers of the theater. From left to right are (first row) Angela McCauley, Richard "Runt" Trantham, Dorothy Radoff, Richard Trantham, Juanita Burgess, and Lenore Rigler; (second row) Gloria Mirza, Oradelle Mozzetti, Janice With, Lila Strassburger, Wally Burke, Pat McCauley, John Clancy, Geneva Johnson, and Delores Van Kirk.

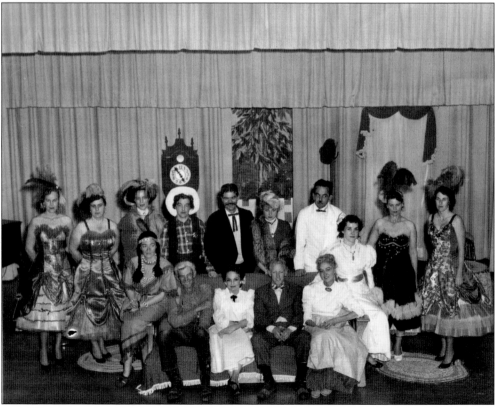

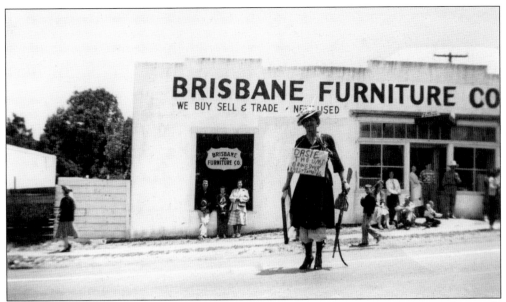

Dick Hosking dresses up as "Daisy the Ump" for the Donkey Baseball Game in 1947. The parade on Visitacion Avenue preceded the game, and most of Brisbane attended this hilarious event. The Brisbane Furniture store was owned by the Fogleman and With families with a house in the rear. This is now the site of the Midtown Market parking lot at Visitacion Avenue and Mendocino Street.

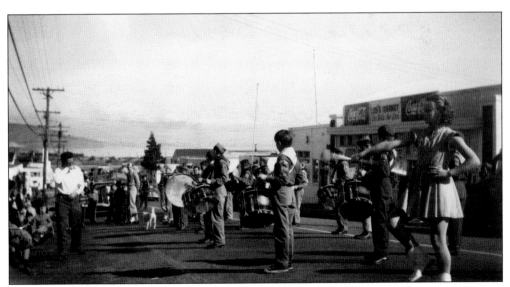

The Brisbane Boy Scouts won many ribbons and trophies in competition performances for their Brisbane Drum and Bugle Corps. They are performing here in 1951 in front of 250 Visitacion Avenue. Dick Hosking and Mr. Brady directed the group.

Raised in Brisbane, Dorothy Radoff was always a strong advocate of the town. She loved history and working on genealogy. Here Dorothy is shown at Brisbane Library History Night. She and Dolores Gomez began collecting older residents's photographs of early Brisbane. They have documented how it was "way back then" in the Brisbane Library Historical Collection and Dorothy's "Brisbane Bygones" columns in the *Brisbane Bee* newspaper. The city, and rightly so, recognized Dorothy as Brisbane's "resident historian." Dorothy passed away in August 1992, a great loss to Brisbane.

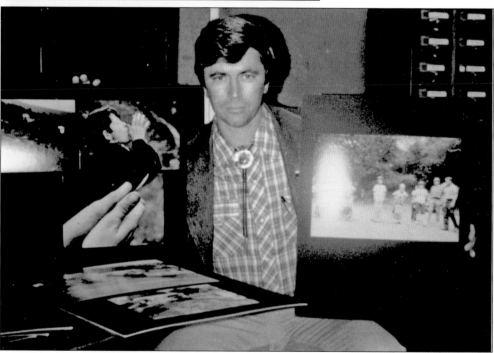

A young man in 1978 was constantly seen around Brisbane with a camera. Bill Owens took many shots of residents just doing their regular regime. Owens kindly donated a collection of his photographs as well as ones he was given by local residents to the Brisbane Library Historical Collection. These were displayed at this Brisbane History Night at the library in 1978. *SUBURBIA*, published in 1970, Owens's book on people and how they live, is in the Brisbane Library Historical Collection.

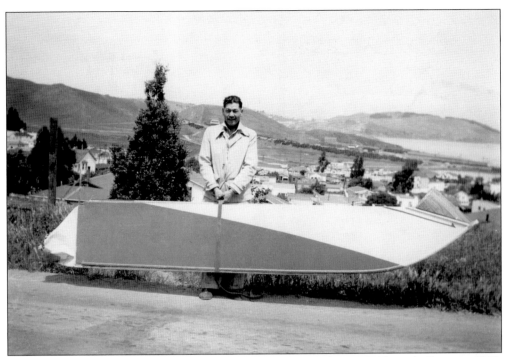

Ben Randrup shows his invention of a collapsible boat across from 432 Alvarado Street in 1940. Ben, coming to Brisbane in 1930, found only about 100 houses.

Longtime resident Lorene Harris (left) brings a petition to sign in 1964 to Anita Collar (center) and Andrea Villar. (Courtesy of Harry P. Costa.)

Ernie Conway visited his brother in Brisbane in 1946 from Oklahoma and did not leave. He married Lucy "Jimmie" Ball and they raised their children—Larry, Dale, Craig, Clark, and Kitty—in Brisbane. Ernie had strong opinions; thus he became one of the first Brisbane council members, serving from incorporation in 1961 to 1966. Clark followed in his dad's footsteps and also became a council member in later years. After Ernie moved to Oroville, he always came "home" to visit; he passed away in June 2008.

At 44 Visitacion Avenue, the Lillian DeMarco Building today stands where the Brisbane Theater used to be. Remodeled after the disastrous fire in 1959 that destroyed the abandoned theater, the building was named after the wife of John DeMarco, owner of the 23 Club. It became the town's city hall for many years and today houses offices, that of San Bruno Mountain Watch among others.

This photograph in the snow atop San Bruno Mountain in 1932 shows Pete Cutney with a backdrop of the town looking north to San Francisco in the distance. San Francisco Bay is at the top right.

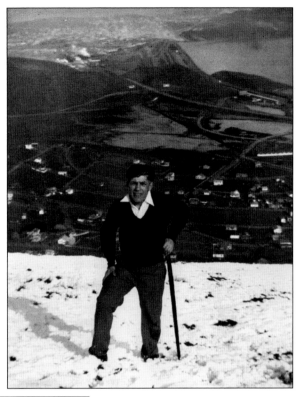

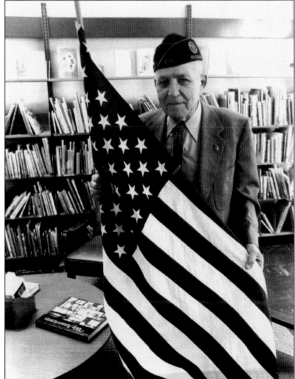

Looking for painting jobs in 1929, Pete Cutney moved to Brisbane and lived at the Allemand Hotel. Cows grazed, wild oats grew high, rabbits cooked with polenta were delicious, fish were eaten from the bay, and when a grass fire threatened, the whole town went to fight the fire. Pete was active in the companionable life in Brisbane, joining the Social Club, where dances on Saturday nights were 25¢. He was also a staunch member of the American Legion Walter Blair Post No. 473. He is shown with the flag that flew over Washington, D.C., and, with pride, was donated to Brisbane City Hall in 1978.

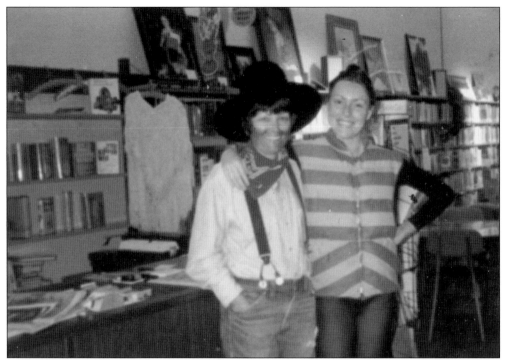

Library staff members Dolores Gomez (left) and Christy Thilmany are dressed up for Halloween in 1979 when the library was located at 245 Visitacion Avenue next to Midtown Market.

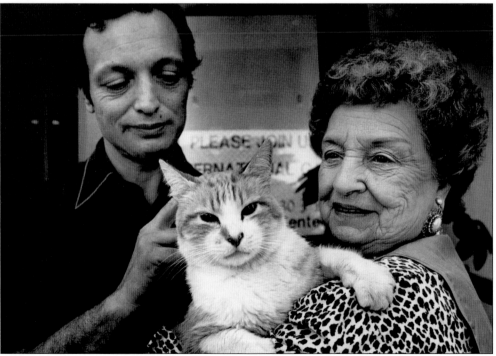

Albert Druo and Lorene Harris admire the friendly and well-liked library cat, Bobby, in this 1975 photograph. (Courtesy of Harry P. Costa.)

Three

BRISBANE KALEIDOSCOPE

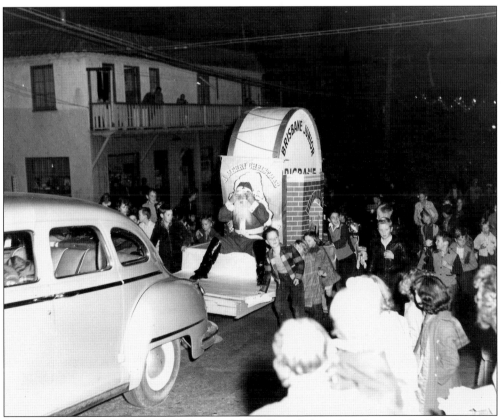

Sponsored by the Brisbane Lion's Club around 1950, Santa helps to hand out small gifts to Brisbane children at their annual Christmas parade.

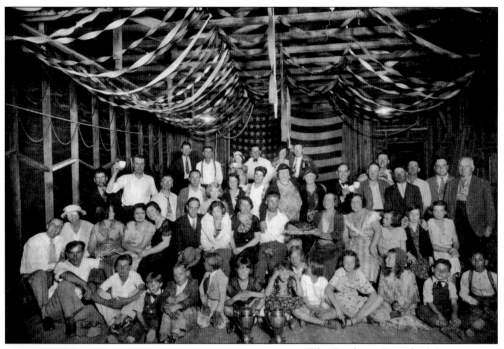

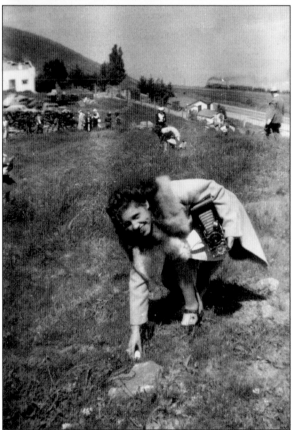

The Brisbane Social Club was created to bond early residents together during hard times in the 1930s. Money was short, and with some unemployed, Brisbane residents shared events with dancing, food, and just having a grand time.

The Brisbane Lion's Club always sponsored the well-attended Easter egg hunts in spring, and it continues to do so. Dorothy Cole is shown gathering an egg on a Crocker land area in 1947.

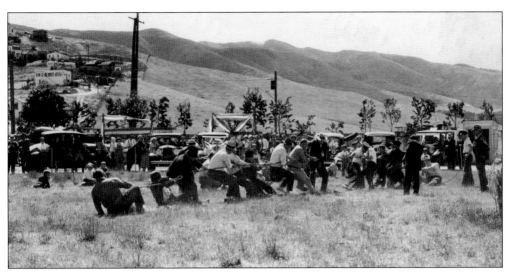

People attending the Fourth of July parade in 1935 rooted for either the Brisbane Volunteer Fire Department or the veterans of World War II in this tug-of-war. It was a clear day with San Bruno Mountain in the background for this event held at Mozzetti's Auto and Trailer Court. Among the strong men were Amos Kinney, Pete Cutney, Harold Drummond, "Sarge" Blair, Chet Winger, Frank Druhan, Roy Rewes, Al Adams, Lou Terry, and Milt Jensen.

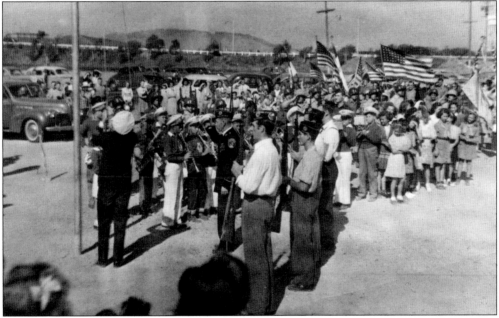

Finally Brisbane had a recreation center and had a big celebration on a sunny day, October 12, 1946. Of course, there was the parade down Visitacion Avenue, with the Veterans of Foreign Wars, Brisbane Boy Scouts, Girl Scouts, Blair's Rangers, the elementary school band, and hundreds of celebrants. The recreation center was at the corner of Visitacion Avenue and the "dog leg turn" at Old County Road. In 1946, Visitacion Avenue went straight out of Brisbane to Old Bayshore Boulevard, now part of Crocker Industrial Park. On one side of the entrance was a ball field and, on the other, a large lagoon, with seepage from San Francisco Bay. Brisbane Village shopping center now occupies the site.

Brisbane was self-sufficient in 1948. Few families had automobiles, and they did their shopping in Brisbane at Johnny's Market (owned by Joe DeMarco) and Gil's Drug Store, on the southeast corner of Visitacion Avenue and Mariposa Street. The drugstore, a strong focal point in the 1930s and 1940s, had a soda fountain with a marble counter, fully stocked for the needs of the community, a helpful druggist, and a library until liquor was sold. The library was moved to 35 Visitacion Avenue when liquor began to be sold at the drugstore and parents didn't want their children to walk by the displays. It burned down on Thanksgiving Day in 1949, leaving Brisbane without a drugstore for many years.

The Brisbane Athletic Club car cruises in front of the 101 Club, the shoe repair shop, and the shoe store in the 1948 Western Day Parade. At this time, the 101 Club was a temporary drugstore, and Al's Shoe Repair was next to the shoe store.

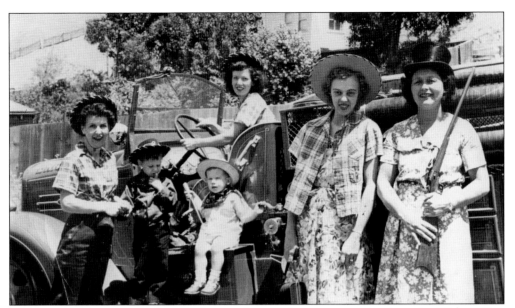

Here in 1952, the women of the Brisbane volunteer firemen are getting into the Western Day Parade act. Pictured to the left are Juanita Seiss, wife of fire chief Dick Seiss, and Rocky McLain. Seated in the Indiana fire truck are Violet McLain and the Mays' child. On the right are Frances Mays and Hazel Hosking with the gun. Residents enjoyed the fun of Western Days when it was a hometown event. In later years, it became too boisterous, and the enthusiasm and sweet simplicity of a small-town parade was lost forever. This was taken across from the firehouse at San Bruno Avenue and Glen Park Way.

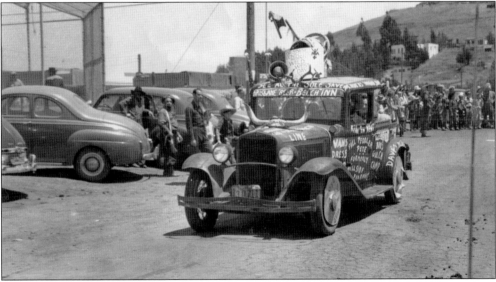

This is the intersection of Visitacion Avenue and San Francisco Street around 1950. The road out of town was blocked by booths set up for residents to try their luck after the parade. Old County Road, which went out to Mozzetti's Gas Station on Old Bayshore Boulevard, had to be used to leave Brisbane. Everyone loved the parade with homemade floats, Cub and Boy Scout units, the school band, and anyone who wanted to join in. In later years, Western Days became commercial, rowdy, and unpleasant with too much drinking and a town filled with strangers.

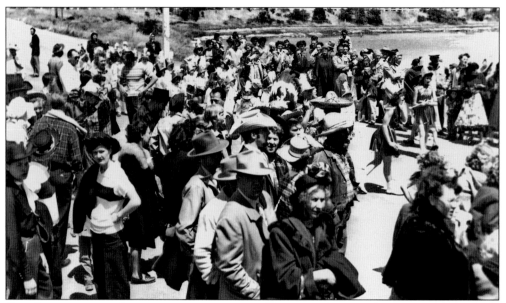

Crowds are enjoying the entertainment covering Visitacion Avenue, the road into and out of Brisbane, in this 1952 Western Days celebration. Visitacion ran straight out of Brisbane to the Bayshore Highway, now Bayshore Boulevard. On Bayshore was a truck stop and repair garage with a popular café that served "Chicken in the Basket." The pond on the right, water from San Francisco Bay, contained large amounts of algae. It was later drained and is now the site of the Brisbane Village.

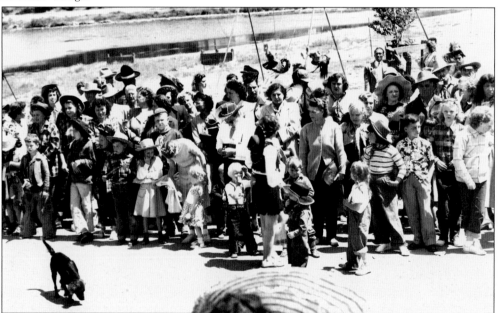

Kids are loving the swings at the Brisbane Recreation Center in 1952. The dress proves residents were out to celebrate Western Days again. Mozzetti's barn appears in the background with an arrow on the fence, pointing to the Mozzetti Motel. The road is Old County Road, now the main entrance to Brisbane. The water pond from San Francisco Bay is yet to be filled and the Brisbane Village, with stores and offices, is yet to exist.

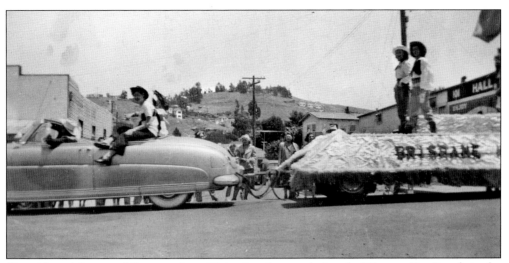

Cowgirls and decorated floats go down Visitacion Avenue during the Western Day Parade in the 1940s. Note the bare hillsides in the background.

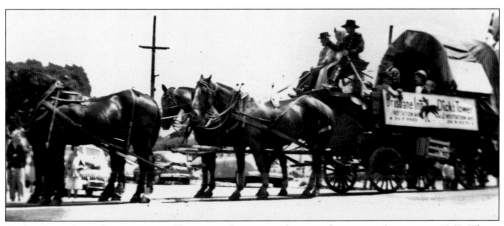

Dick's Tower brought in a team of horses with a covered wagon for its parade entry in 1952. There was always someone sweeping after the parade.

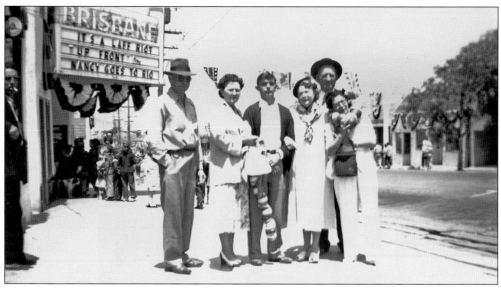

A group of celebrants during Western Days 1952, in front of the Brisbane Inn, poses for this picture. The Brisbane Theater had a line ready to view the movies and a double feature.

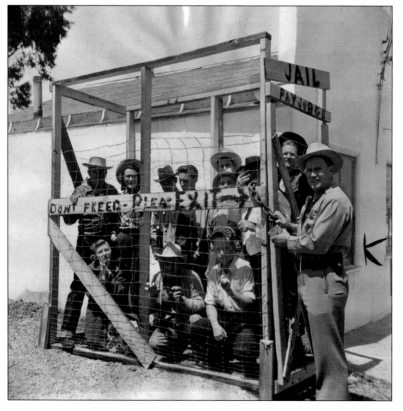

For Western Days in May 1950, a kangaroo court had been set up in fun to jail these "bandits." Revelers were pulled off the streets for a brief stay in the hoosegow. Western Days lasted from Friday through Sunday. In 1950, there was a carnival at the old entrance to Brisbane and a parade was held on Saturday. (Courtesy of San Francisco History Center, San Francisco Public Library.)

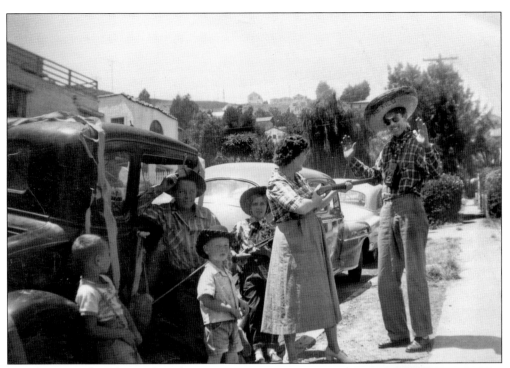

Just playing to the Western Day theme on Mendocino Street in 1952 are, from left to right, Randy Watson, Gary Romriell, Steve Coffee, Claudia Cosby, a neighbor with a gun, and "Slim" Coffee.

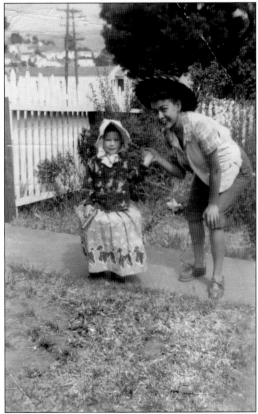

Bernice Lummus Blanchard gets ready for Western Days in 1952 with her daughter Jackie. Bernice and her family moved to Brisbane in 1929, when chickens and cows roamed the narrow unpaved streets.

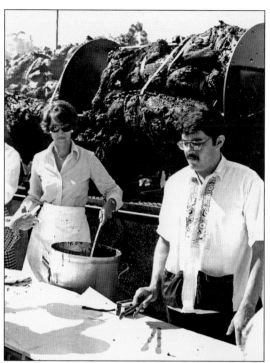

Brisbane City Council members were always there to help at DeMarco's well-attended barbeques. Long tables were set up in the parking lot in warm weather for hundreds to enjoy. On September 16, 1973, cited in the *Guinness Book of World Records*, nearly 4,500 were served in a spectacular buffalo feed. Here Anja Miller and Art Montenegro serve participants, while behind them are huge sections of buffalo on a specially made rack. Anja and Art both served as mayors and Brisbane City Council members.

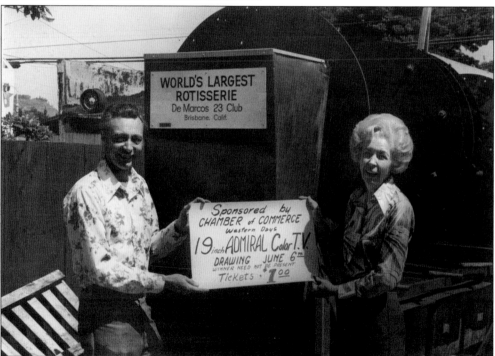

Holding the sign for the Brisbane Chamber of Commerce barbeque in 1965 are Don Bradshaw, Brisbane mayor 1970 to 1980, and Clara Weitzman, secretary for the Brisbane Chamber of Commerce. Members of the chamber produced many successful events at DeMarco's 23 Club. (Courtesy of Harry P. Costa.)

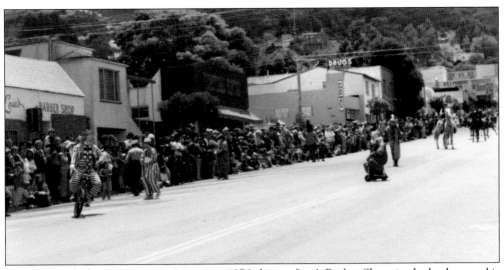

Clowns parade down Visitacion Avenue in 1976 close to Lou's Barber Shop; in the background is Robert Stone's Drug Store at 101 Visitacion Avenue. Stone had a popular, full-service drugstore that also sold nice gifts. In later years, he retired, a loss to the community, but by then residents were driving out of town to chain drugstores to purchase their prescriptions.

Local residents dress up to march in the 1952 Western Day Parade. In the background, the Gay Nineties, a popular stop in Brisbane, was run by the well-liked Marge McLennan, wife of former councilman Robert McLennan. The Gay Nineties sold gifts, toys, cards, hot dogs, ice cream, and popcorn, and there was even a layaway plan for children to purchase gifts.

Always ready for a parade, students of Brisbane Elementary School Barbara Schwenderlauf (left), Joan Randrup (center), and Shirley Schwenderlauf stand on El Dorado Street in front of the school on El Dorado Street. The homes and lots surrounding the school were taken by eminent domain in 1963 to expand the property and yard of the school. A spirited fight was waged by those affected.

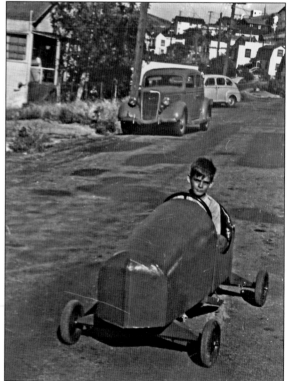

Ray Vuillemainroy shows off his soapbox derby car constructed by Ray and his dad. Residents lined San Bruno Avenue to view this popular event for the town in 1940.

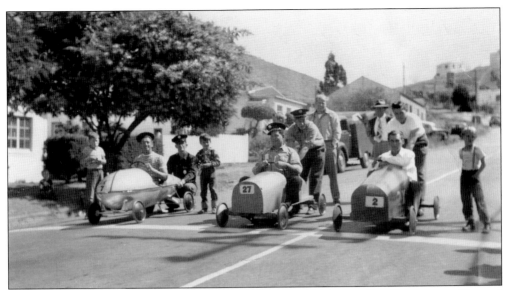

The popular soapbox derby was sponsored by the Brisbane Volunteer Fire Department. Pictured here across from the elementary school on San Bruno Avenue are some of the volunteers sitting in the crafty entries. Pictured in 1940 from left to right are unidentified, Larry Mills, and Ray Vuillemainroy Sr. getting ready to start at Santa Clara Street and San Bruno Avenue.

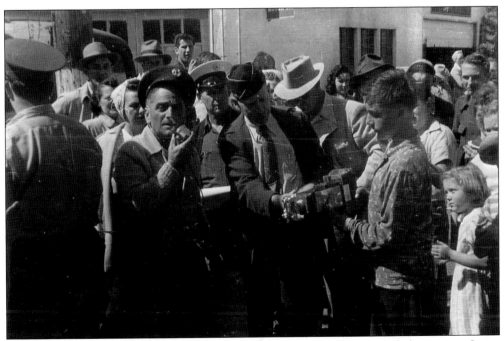

Lou Terry, Brisbane Volunteer Fire Department fire chief, announces second-place winner Louie Brown, who accepts a trophy from John Fassett of the Brisbane American Legion. Louie's dad, Norman Brown, was an early volunteer fireman. The first-place winner in this 1948 soapbox derby was George Babkirk.

The Brisbane Theater was usually packed with those who enjoyed the appealing double features of the early 1940s. It was pure entertainment with a dish night for the ladies and Spino, a game where one could win groceries, a flashlight, or a $5 voucher from the Brisbane Hardware Store. Huntz Hall, one of the Bowery Boys, was a big hit in town when he visited the theater in early 1950 after moviegoers saw a "Bowery Boys" movie. After the movie, there was a well-attended reception at DeMarco's 23 Club for Hall. The theater was Brisbane's great attraction before and after World War II. After the advent of television, business at the theater declined, and in July 1959, fire gutted the abandoned building.

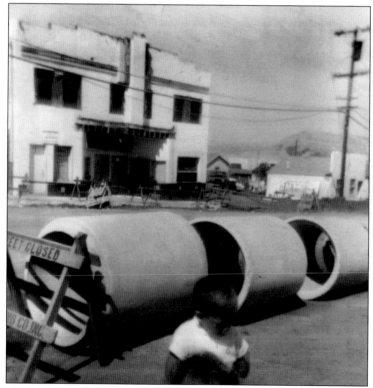

In 1961, residents, threatened with "urban renewal," voted to incorporate Brisbane. The citizens wished to be independent, to make their own choices instead of letting San Mateo County do so. In this November 1961 photograph, Visitacion Avenue is closed; huge drainpipes lie ready for a new street without the deep gutters that had previously lined Visitacion. The burned theater was remodeled in 1968 and named the Lillian DeMarco Building.

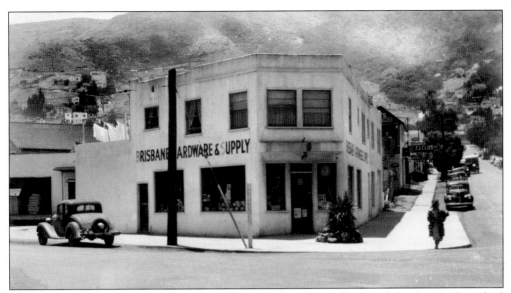

In the 1940s, wash was hung out to dry and not too many owned automobiles, but Brisbane had a hardware store. Brisbane's first hardware store was owned by George Heywood and was located at 301 Visitacion Avenue. By 1940, Dick and Thyra Schroeder built a new one that still stands today along with the same tree, only slightly taller, in front.

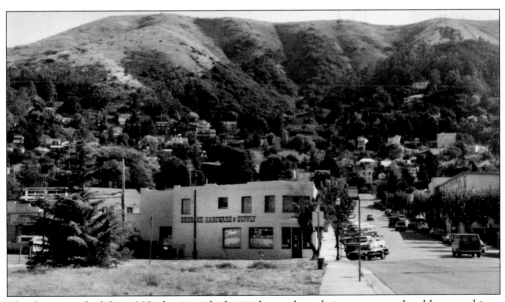

The foreground of this 1992 photograph shows the neglected city property that blossomed into the beautiful Community Park after a vote by citizens. Brisbane Hardware is just beyond the property with Visitacion Avenue running straight into town.

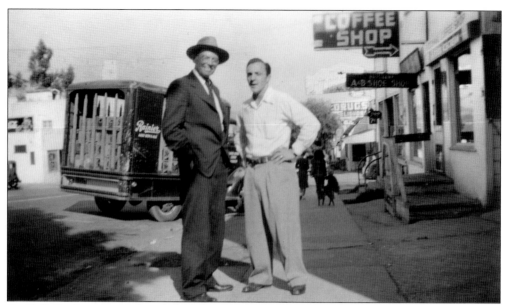

By 1947, Brisbane bustled with four markets, a shoe store, a woman's dress shop, a 5-and-10¢ store, a drugstore, several churches, and four bars. During the war, few had automobiles, gas was rationed, and the town was self-sufficient.

In the early 1960s, Frank Rossini and "Butcher Herb" managed the Midtown Market at 185 Visitacion Avenue. In 1961, the operation was bought by likeable brothers Bob (seen here) and Ernie Rossi. Amiable Bob Fanucci served as butcher for the market. Business grew, and in 1966 the store was moved to 249 Visitacion Avenue; it soon became a family business, with the Rossi children taking over chores. After 30 years of keeping a store that served the community well for residents, the Rossis retired from Midtown Market to enjoy time with their families.

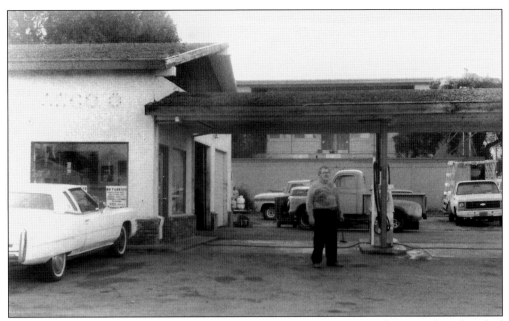

Gil Gilbrech bought the gas station at 1 San Bruno Avenue from Lester Bybee in 1951. Gil worked the busy full-service station with partner Warren Reese and later with Louis Scott. Retiring in 1983, Gil's son John managed what was still known as Gil's Gas Station. Gil and Marie's children, John, Danny, and Gail, all attended the Brisbane school. Gil enjoyed being a member of the Brisbane Lion's Club; he passed away in 2000.

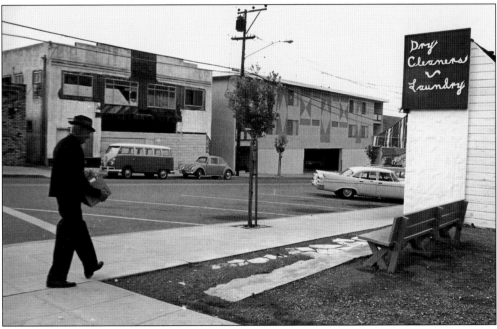

By 1963, Visitacion Avenue was a wide, improved flat street and gutters with rushing waters were gone. The burned-out theater at left was on its way to being remodeled for offices. The huge pepper trees that broke up the sidewalks were taken out and replaced. The dry cleaners at 45 Visitacion Avenue had a new awning, and Brisbane had an apartment building at right.

The Brisbane Parent and Teachers Association was active, raising money for the school. They had a popular Halloween Carnival at the elementary school each year with booths, food, and lots of fun for families. Once a week, a hot lunch was cooked for students by moms to raise funds for special school needs. Persons being installed in early 1960 are, from left to right, principal Monte Rice, Marion Vickery, Betty Roesch, Margaret Galten, unidentified, Theresa Monahan, Oradell Mozzetti, Delores Van Kirk, Jack Grabovsky, principal Lois Barrett, and Byron Jensen.

For many years, Brisbane had a Well Baby Clinic where mothers brought babies for their checkups and shots. Doctors and members of the community donated their time to this fine cause and free care in 1955. At first, the clinics were held at the American Legion Hall at 250 Visitacion Avenue and later at the Brisbane Elementary School. From left to right are Vera Blair, Stella Smith, Louise Fassett with a baby, two unidentified, and Mrs. Earl Woodard.

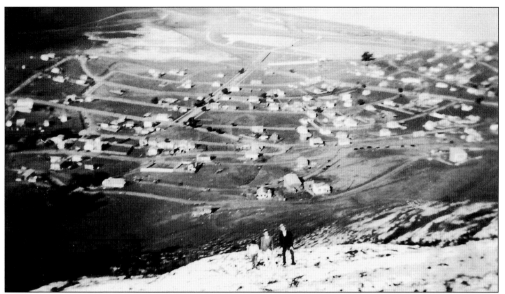

Brisbane was devoid of trees, but cars and homes were beginning to dot the town. Some hearty hikers braved snow to hike San Bruno Mountain in this 1932 photograph.

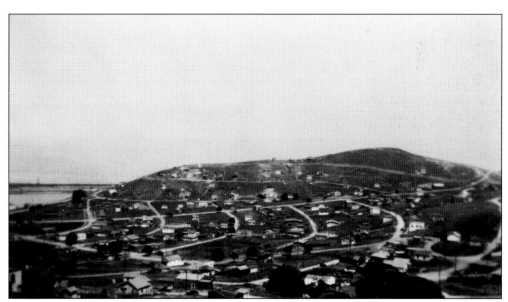

The fan-shaped design of Brisbane's central area can be seen in this 1932 photograph. San Bruno Avenue runs straight up the slight hill, which overlooks Sierra Point. Homes were beginning to be constructed, and it was estimated over 100 homes dotted the area.

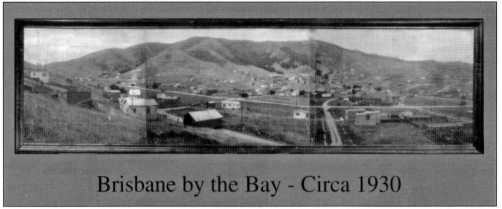

Brisbane by the Bay - Circa 1930

This *c.* 1930 picture hung in the old Tract Office on Visitacion Avenue and Mariposa Street. Note the many small homes and the sign "Brisbane by the Bay" on the slope of San Bruno Mountain. This large photograph can be seen at the Brisbane Library on the wall of the reading room and was used by the Friends of the Brisbane Library to be made into a postcard to raise money for the library.

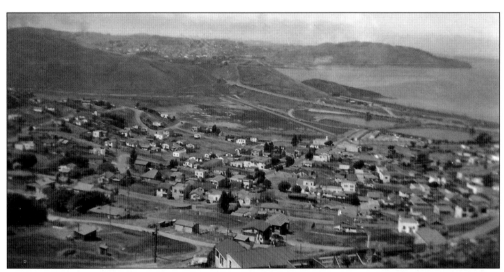

In late 1930, on each side of the main road to the highway was seepage from San Francisco Bay. The left side was about to be filled, forming a field for young Brisbane baseball players. The right side, full of algae, was left as it was until filled for the Brisbane Village Shopping Center in 1979. There were still vacant lots waiting to be filled on Visitacion Avenue. Dick's Tower served music and delicious dinners, and the long, covered Hetch Hetchy pipe stretched across the front of Brisbane. Candlestick Point can be seen in the extreme right background.

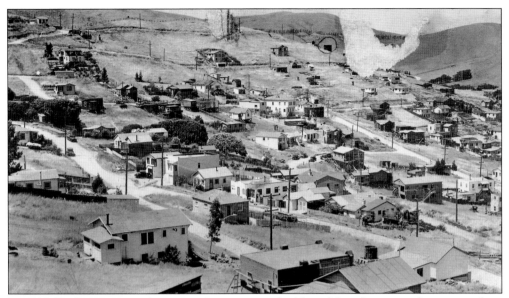

By 1937, Brisbane was on the way with continuous building. Many homes in this picture show different stages of construction. In the immediate foreground is San Benito Road. Note the absence of automobiles.

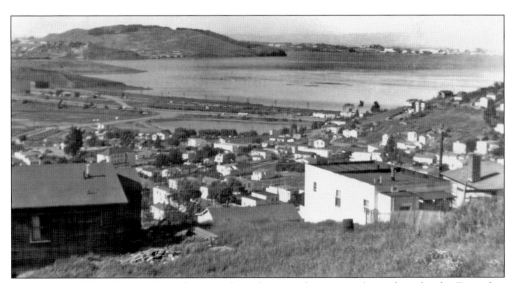

In the upper left of this *c.* 1940 photograph, railcars are leaving with produce for the East after having been iced at the icehouse. Broken large chunks of discarded ice were gathered by Brisbane residents for their home iceboxes.

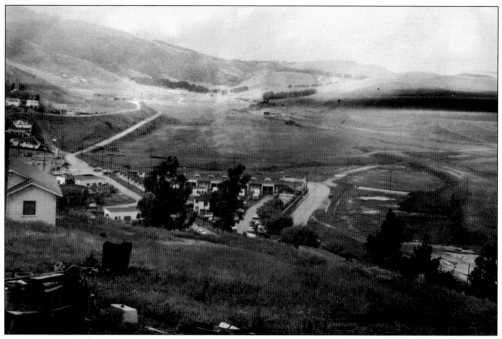

Lipman Middle School can be seen at left in this *c.* 1950 photograph. Residents could no longer drive straight out to Bayshore Boulevard on Visitacion Avenue but would have to make a turn onto Old County Road, which then curved out to Bayshore.

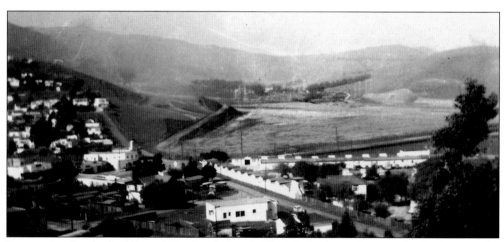

Preparation for the building of Crocker Industrial Park is in the early stages here; gone are the Hetch Hetchy water pipe and the wet areas with frogs; the seepage from San Francisco Bay is filled in, and the recreation center near the old entrance to town moved to Solano Street.

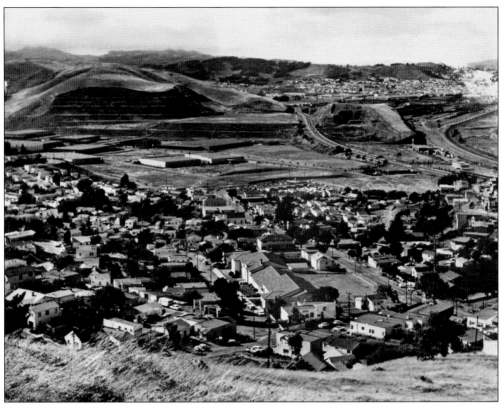

Southern Pacific train yards and the new road into Crocker Industrial Park from Bayshore Highway are clearly seen in this *c*. 1956 photograph.

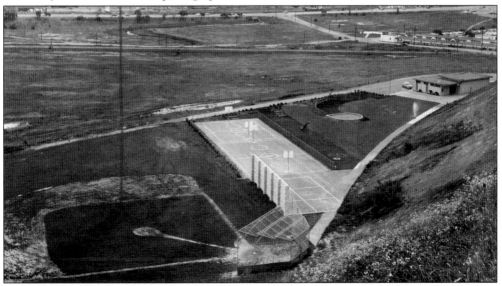

Looking down from Humboldt Road in the 1950s, the Brisbane Recreation Center basketball court and baseball diamond sit above the cleared marshy land, and Visitacion Avenue goes straight out to Bayshore Highway, now Old Bayshore Boulevard. Also visible is Mozzetti's Auto Court and Trailer Park and the stretch of Hetch Hetchy pipe. (Courtesy of Harry P. Costa.)

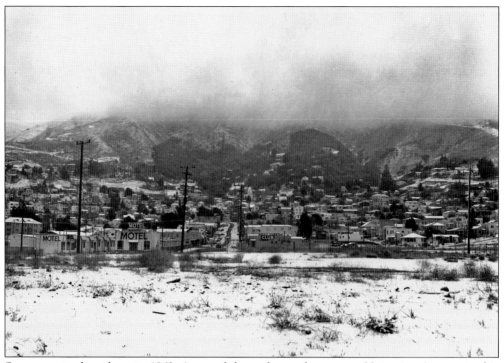

Snow surprised residents in 1962. Automobile tracks can be seen on Visitacion Avenue in this scene. Crocker Industrial Park is now in the foreground area.

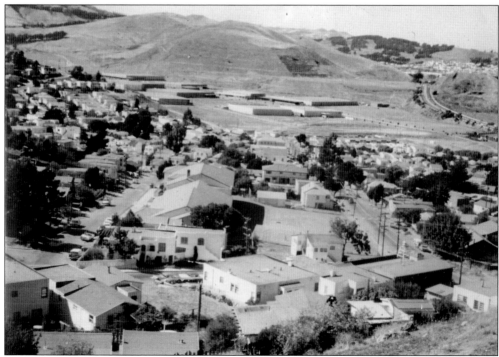

By 1963, Crocker Industrial Park was on its way to completion, and El Dorado Street, with many homes and lots, was in the process of being acquired by the school district.

San Bruno Avenue, at bottom going across the image, went past Annis Road, at left. Humboldt Road, running between the houses across the image, had a few homes spread out on the hillside in the 1940s.

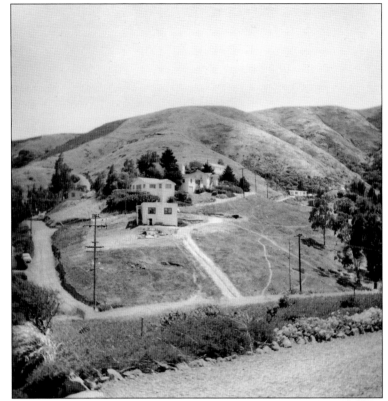

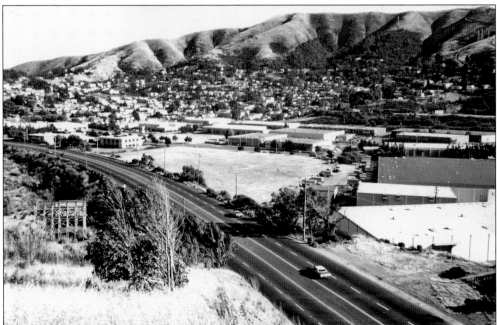

Taken in 1975 from "Gun Club Hill," the northeastern side of Bayshore Boulevard across from Brisbane and looking south into Crocker Industrial Park and Brisbane, this image shows the few automobiles on the Bayshore Boulevard, also known as the Bayshore Highway.

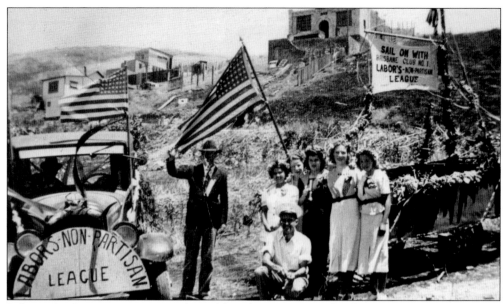

Labor's Non-Partisan League was formed by John L. Lewis and Sidney Hillman, leaders of the Congress of Industrial Organizations (CIO). Its purpose was to unite all workers, regardless of union or political party affiliation, to campaign to elect Franklin D. Roosevelt in 1936. In the years after the election, the league, involved in local elections, pushed for continued support for New Deal legislation. Here a local group of the league proclaims its support in the late 1930s on San Bruno Avenue. On the hill above is a house under construction by a German man who brought bricks home in a bike basket from sites in San Francisco. As the house was abandoned later, the bricks disappeared as Brisbane residents used them for their own homes.

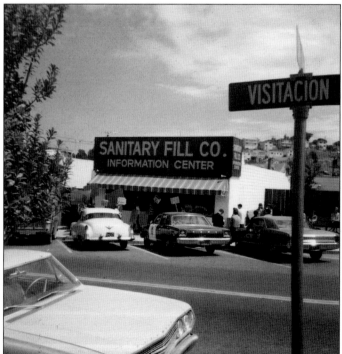

The Sanitary Fill Company Information Center rented 45 Visitacion Avenue in 1967 to promote their plans to fill the Sierra Point area with garbage. The town was strongly divided on their vote.

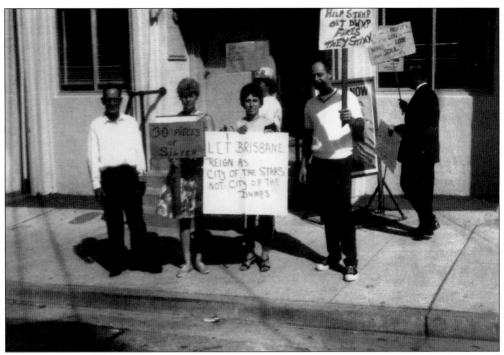

Anti-garbage residents picketed daily in front of 45 Visitacion Avenue.

Even youngsters, waving their signs, joined in the garbage fight in front of the Sanitary Fill Information Center in 1967. From left to right are (first row) Clark Conway, John McEvoy, Harry Waltz, John Burr, and Tracy Lily; (second row) Craig Conway, Bobby Schoolcraft, John Lily, and Randy Romriell. The majority of the kids still live in Brisbane. (Courtesy of Harry P. Costa.)

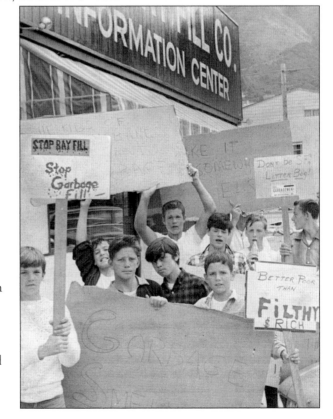

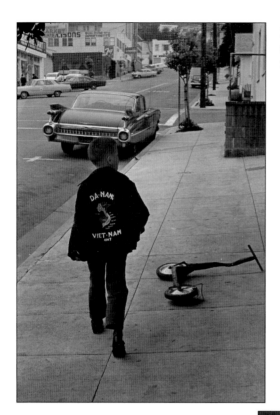

Danny Navarro, wearing a jacket sent by his uncle who was serving in Vietnam, strides in front of 160 Visitacion Avenue in 1967.

"Operation Snowball" began in the 1960s by Jo Stacer, Betty Gwinn, and Marion Vickery, who were concerned with Brisbane's servicemen and women. They sent care packages filled with gum, nuts, hard candy, flints, and small gifts during the holidays. Donations from residents paid for the items and for mailing to those in the United States and overseas. Many letters were received with appreciation from those in the service to the Operation Snowball ladies.

Anna Lou Martin (left) and Margaret Galten (back right) help a donor weigh rags for the Parent Teachers Association's rag drive in 1958.

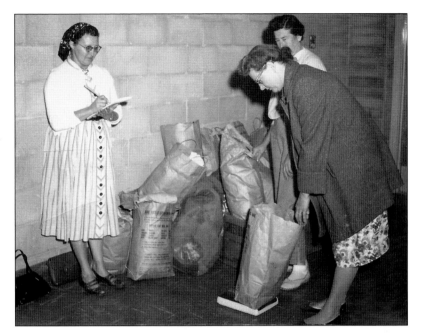

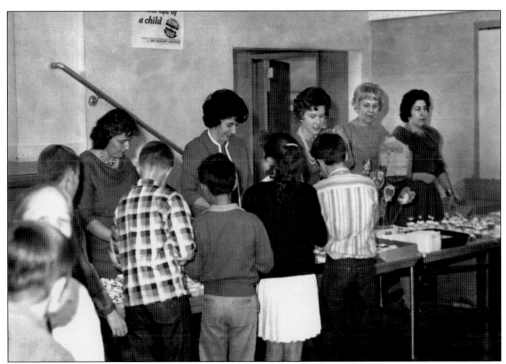

Members of the Parent Teachers Association serve cupcakes to students at the Brisbane Elementary School in 1963. From left to right are Dora Allemand, Delores Van Kirk, unidentified, Miriam Brady, and Vincetta Salmon.

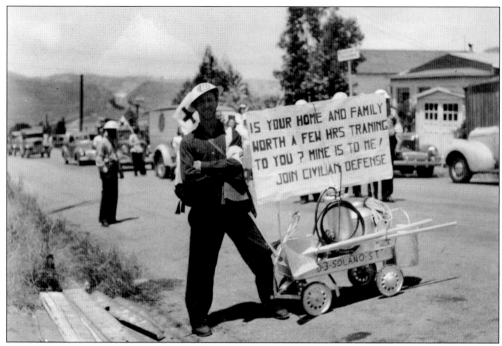

Join Civilian Defense! That was the cry in July 1942 with a parade up San Bruno Avenue. During World War II, the civil defense team of Brisbane learned first aid and how to protect the town during a black out or an air raid.

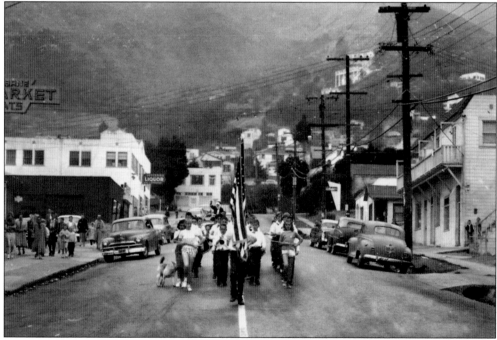

Santa is led by the Drum and Bugle Corps down "old" Visitacion Avenue in early 1950. The building on the right, at Visitacion and Mendocino Street, still had a balcony, and the hills were not filled with homes.

In December 1959, Brisbane's Lipman School Band with majorettes marched for the Christmas parade down Visitacion Avenue.

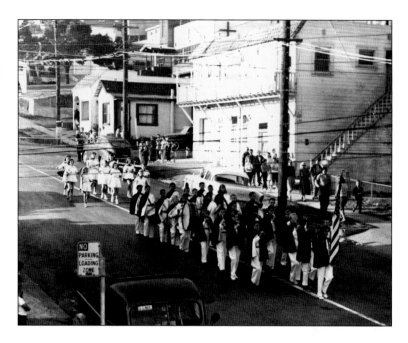

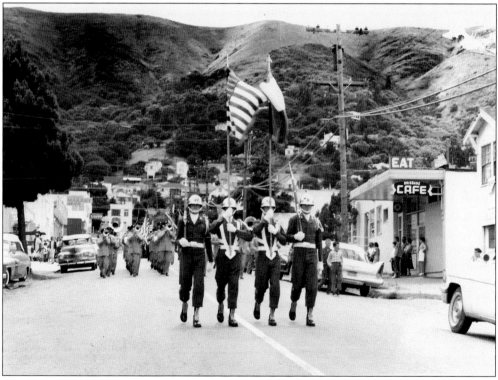

Another celebration was held for the relocation of the Brisbane Recreation Center, from Old County Road and Visitacion Avenue up to 1 Solano Street on June 8, 1958. The U.S. Army Band led the parade in their steel helmets.

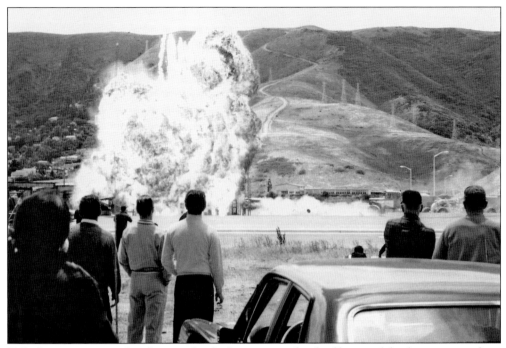

Hillsides were crammed with excited onlookers waiting for the filming of the famous scene from the motion picture *Bullitt*. The roaring Mustang came screaming down Guadalupe Parkway into old buildings waiting to be exploded. Screams were heard from the crowd as the huge fireball erupted. Lipman Middle School can be seen in the background.

It was an exciting time in Brisbane when a scene for the television series *Movin' On* was shot at the Brothers Four restaurant at 301 Visitacion Avenue in the mid-1970s. Ronnie Fager stands beside Claude Akins, star of the series.

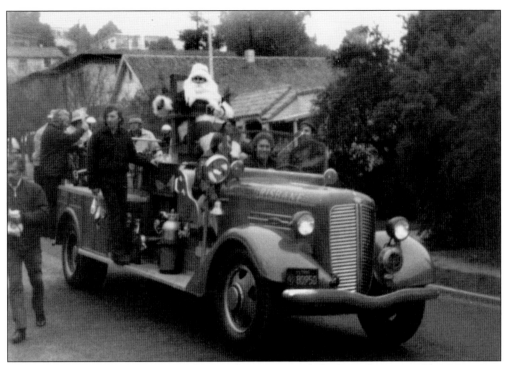

Since the Great Depression era, volunteer firemen provided a bag of treats at Christmas time for Brisbane children, and the tradition continues today. Now sponsored by the Brisbane Lion's Club and with the help of the Brisbane Fire Department, the fire truck, sirens wailing, visits each street and smiling children waiting for Santa to hand out a bag of candies and a small gift. Santa sits on the Indiana fire truck on Monterey Street in 1975.

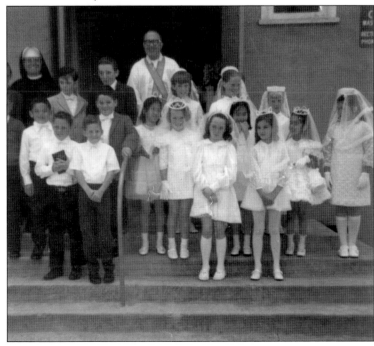

Father Thomas Lacey, Sister Giovanna, and the communion class stand in front of Our Lady of Guadalupe Mission Church on Alvarado Street in 1970.

95

Brisbane's first library was located in the back of Gil's Drug Store on the corner of Visitacion Avenue and Mariposa Street, but protests from parents, when their children had to walk past liquor, changed that. From 1932 to 1934, a room in Lorene Gledhill's 343 Mariposa Street home began the second library in Brisbane. Gledhill received $5 monthly for services and rental. Circulation was 225 items a month. Her husband, Arthur Gledhill, edited and published the town's first newspaper, the *Brisbane Sun*, in 1933.

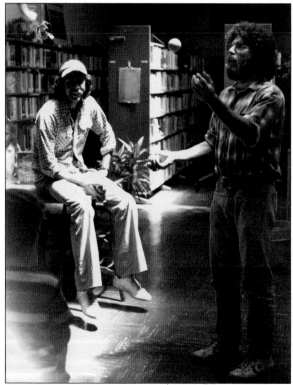

The Brisbane Library, with the help of Brisbane service organizations, provides a variety of children's programs. In 1976, many enjoyed a special juggling program during the summer.

Chuck Ashton, San Mateo County children's librarian, delights the small children with a puppet show in 1986, downstairs from the library in the community center at 250 Visitacion Avenue.

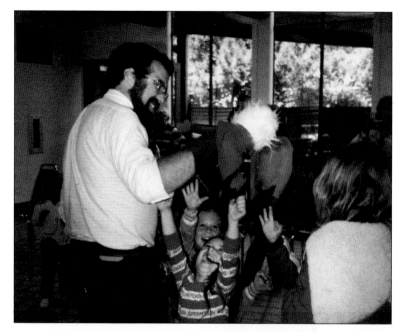

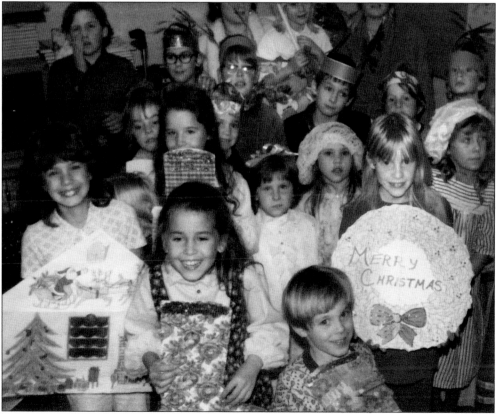

A crowd of happy Brisbane children came to decorate the library Christmas tree at 245 Visitacion Avenue in 1973.

The chef helps Vickie (center) Hobson and Nugget Towle plan the menu for the Federated Women's Club of Brisbane's fashion show in front of the 23 Club in 1970. (Courtesy of Harry B. Costa.)

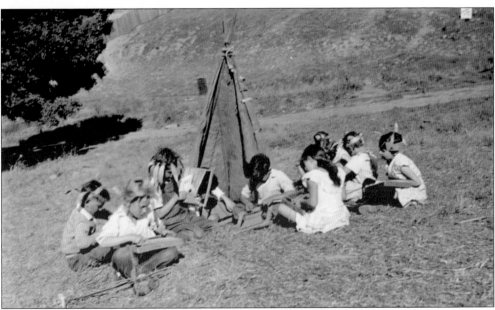

Students from Brisbane Elementary School, on a school project, sit on the Brisbane hillside building a Native American teepee in 1935.

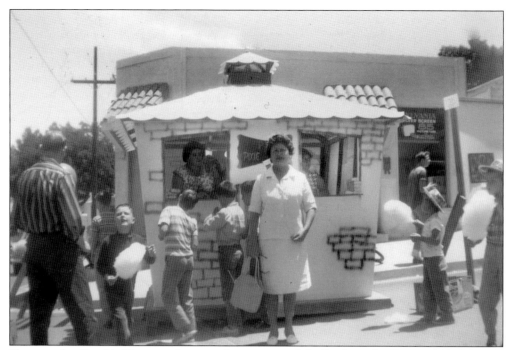

Photographer Frankie King, an advocate of art, sponsored the Brisbane Art Fair in 1963. A variety of artists displayed their work from Brisbane and all over the Bay Area on Visitacion Avenue.

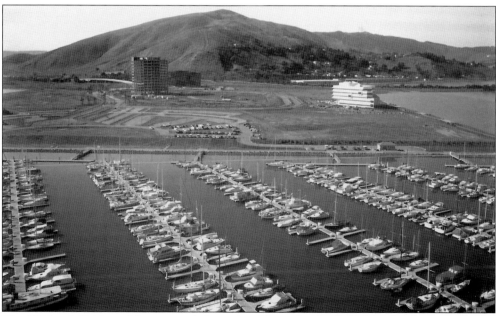

The 600-berth Brisbane Marina was dedicated on November 20, 1983. Most berths were filled by June 1987 with a variety of pleasure boats for those who enjoy sailing on San Francisco Bay.

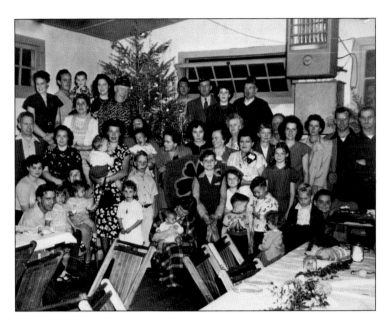

The American Legion hall at 250 Visitacion Avenue, constructed after World War II, became a focal part of Brisbane life. Regular dances, meetings, rummage sales, and special gatherings were held here. This 1950s Christmas party of the post members and their families, with the tree in the background, is a great example of good times in a building now replaced with a library and community center.

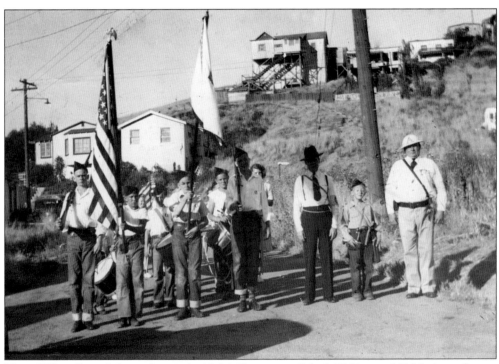

"Sarge" Blair (far right) stands proud with his Rangers on July 4, 1943, near 143 Mariposa Street, with Santa Clara Street high in the background.

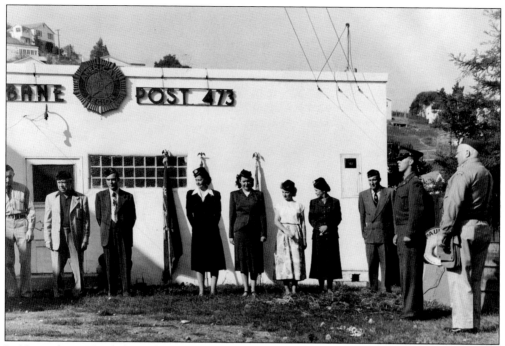

In November 1950, dedicated members of the American Legion Post No. 437, at 250 Visitacion Avenue, gather for a ceremony. "Sarge" Blair stands at attention at right.

Brisbane Seniors have been meeting for lunch since the 1940s. This group in 1977 was ready to board a bus for a special trip. This building at 250 Visitacion Avenue, once the American Legion hall, was redecorated with a star surrounding the front door and became the community center.

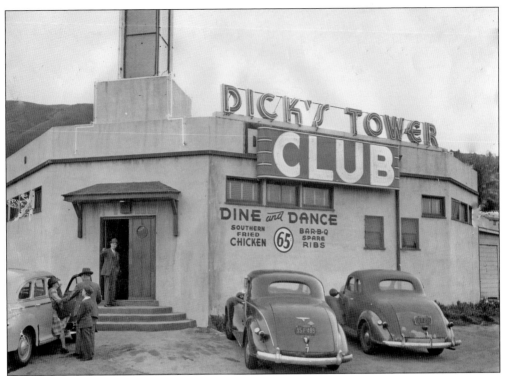

This family was dressed and ready for a tasty dinner at Dick's Tower Club at 2 Visitacion Avenue. This popular eatery served dinners and drinks, and there was dancing on Saturday nights. In 1940, a full dinner at Dick's Tower cost 50¢. (Courtesy of San Francisco History Center, San Francisco Public Library.)

The Voter's League Hall, in early 1930, was at 101 Visitacion Avenue. Later it was a pool hall, and during World War II, dances were held with many servicemen dancing to a live band with local girls on Saturday nights. It became known as the 101 Hall.

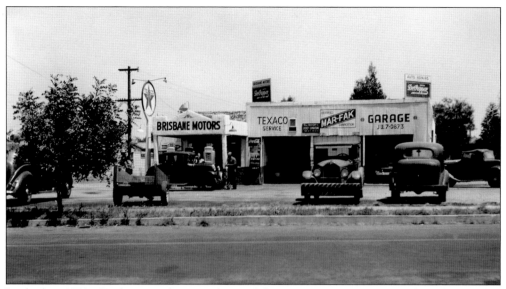

In the late 1930s, Brisbane residents used one of three gas stations in town. Bybee's Texaco was located at 1 San Bruno Avenue.

The Mohawk Gas station at 18 San Bruno Avenue was owned and managed by Bill "Chuck" and Francis May. Daughter Lucille May Smith worked along with her brothers, Bill Jr. and Chuck, pumping gas and checking oil beginning in the early 1940s. From left to right are Francis, Chuck, and Bill May.

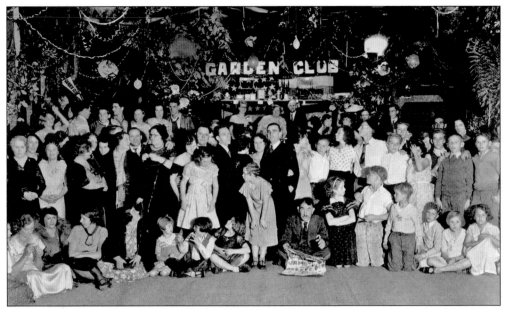

Brisbane was a close-knit community in 1934, when social events like the Garden Club Jamboree allowed most of the town to join in, children included, in these fun potluck occasions.

Women of the Brisbane Garden Club made corsages for the Brisbane Elementary School students graduating each year and also provided colorful table decorations for special city events. For many years, a flower show sponsored by the Garden Club was held at the Brisbane Community Center, attended by flocks of people who came to see the beautiful floral displays of town gardeners.

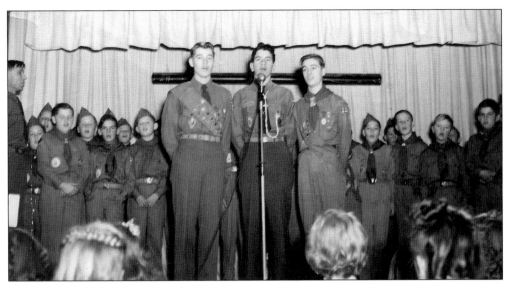

Scouting in Brisbane became a focal group helping with special events and programs, especially in the years 1940–1950. Dedicated scoutmaster Jack Grabovsky (far left) could always be seen with his old Packard filled with scouts. Here his group is performing at the Brisbane Elementary School on El Dorado Street.

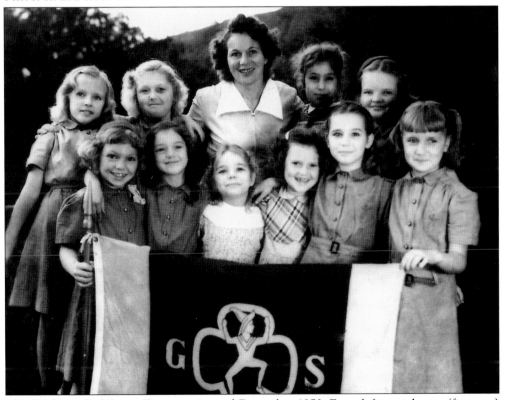

The Brisbane Girl Scout Troop is pictured December 1950. From left to right are (first row) unidentified, Margaret Duncan, Bybee, Joyce Severs, Linda ?, and Shirley Patton; (second row) Christine Jorgenson, Helen Neilson, unidentified, Janice Boardman, and Betty Byram.

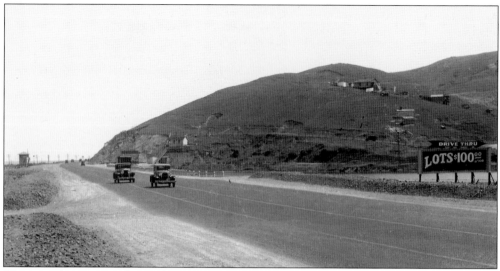

Chugging their way on the Bayshore Highway, the main artery to San Francisco around 1930 that is now known as Old Bayshore Boulevard, automobiles pass a sign offering lots for $100 with the small print stating, "To $300." The cars have passed Mozzetti's Gas Station and are just passing the old entrance to Brisbane. This was during the Great Depression of the 1930s; many found reasonable lots and built homes for their families.

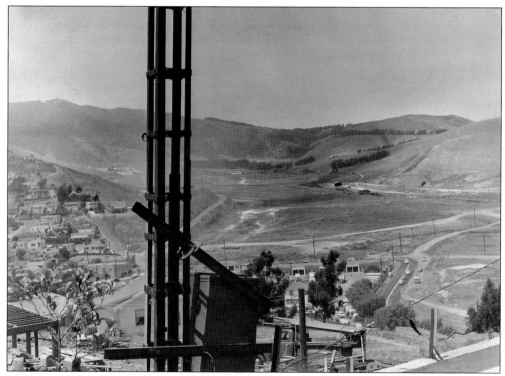

This photograph was taken from the end of Tulare Street in 1949. It shows the very early grading of Crocker Industrial Park, the dogleg turn on Old County Road, the Mozzetti Motel and Trailer Park, Dick's Tower, Brisbane Quarry, Hansen's Ranch, and the beginning foundation of Jack Grabovsky's house, his truck piled with lumber, on Tulare Street.

As time went on, Brisbane was "discovered." The wonderful weather, close proximity to San Francisco, and the small-town atmosphere attracted many people and families to the community. Apartments around town solved some of the housing need. The hillsides became filled with much larger housing during the 1980s.

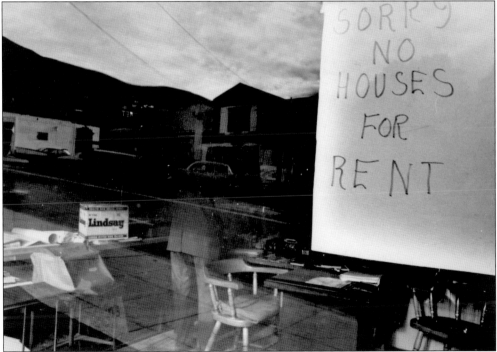

There have been many times in the past 30 years that the local realtor had to put a sign in his window reading, "No Houses for Rent," as home rentals were difficult to find.

In 1956, the Natalie Lipman School, named after one of Brisbane's first teachers and a longtime principal, was dedicated. The Brisbane Boy Scouts, American Legion, and the U.S. Army Band played to the crowd gathered at the basketball court at the Brisbane Recreation Center.

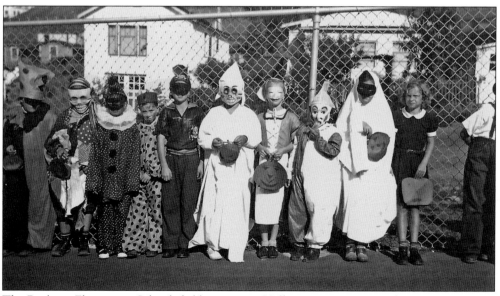

The Brisbane Elementary School children enjoy a Halloween costume parade in 1940.

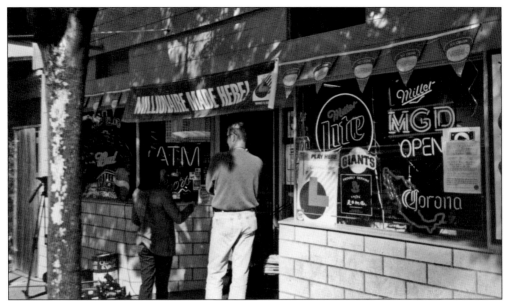

"Millionaire Made Here" shouts the banner above the entrance to Julie's Liquor Store on Visitacion Avenue in 2002. The winning California lottery ticket worth $30.5 million was sold here to Cindy Blair, a 43-year-old office manager of a San Francisco printing plant. The owner of the store, Julie Banks, used the prize money of $152,500, given for selling the ticket, to repaint the sign out front and to remodel the store. This building has been used as a 5-and-10¢ store, printing shop, cleaners, creamery, and a grocery store.

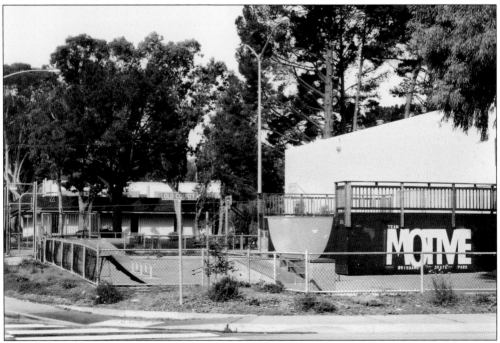

Thanks to volunteers Randy Romriell, Dale Conway, Joel Diaz, and others who worked with the city, a skate park and a basketball court for residents were built at the corner of Old County Road and Visitacion Avenue in 2005.

Longtime resident Marie Hubrig is dressed up in her prairie bonnet for Western Days in 1975.

Shoemaker Ralph Oroquita playfully dons a large shawl and a rose in his teeth for the parade in 1929.

The library at 19 San Bruno Avenue, shown in the background, was managed by Bernice Delbon. Bernice with her husband, Wally, raised their children, Marilyn and Donald, in Brisbane. The library moved from 19 San Bruno Avenue to 245 Visitacion Avenue in 1966. Dick and Hazel Hosking enjoy street dancing during the Queen Contest in 1963.

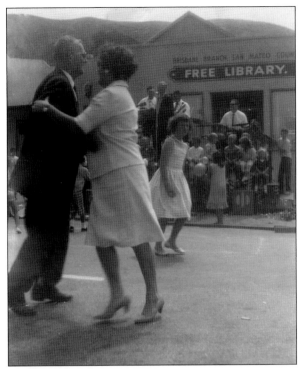

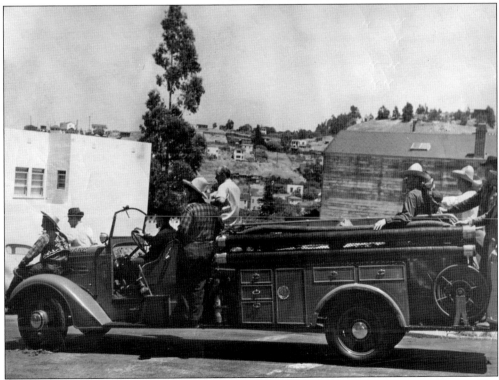

The heavily used Indiana fire truck, driven by volunteer firemen decked out in their Western Day sombreros, passes the vacant lot at Visitacion Avenue and Klamath Street in the 1952 parade.

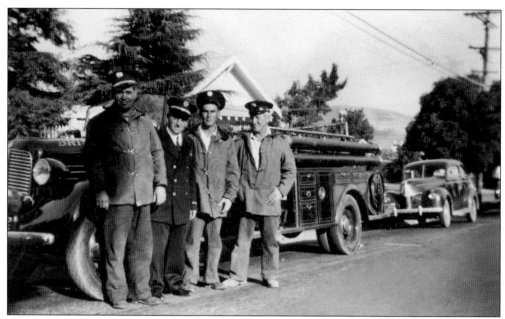

From left to right, volunteer Brisbane firemen Larry Mills, Chief Lou Terry, Ray Vuillemainroy, and Joe Heinzer pose across from Midtown Market on Visitacion Avenue in 1945.

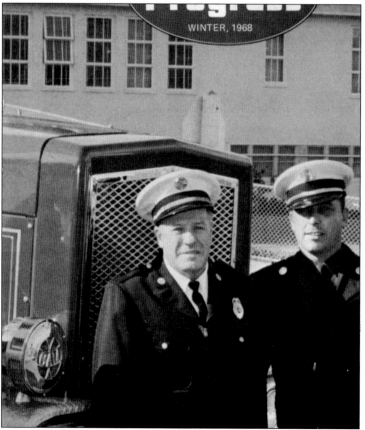

Richard Seiss (left), a Brisbane fire chief for 30 years, and Chief Clarence "Dutch" Moritz, along with members of the fire department in 1964, designed a special pumper that was able to negotiate the narrow roads, sharp turns, and steep hills of Brisbane.

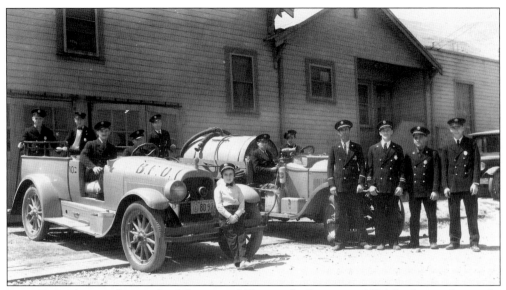

By 1935, Brisbane volunteer firefighters used Heywood's Garage, at 385 Mendocino Street, for their self-made fire trucks. With uniforms from the Salvation Army store and a mascot, Louise Terry, they had a great sense of pride in their knowledge of fighting the constant grass fires that plagued Brisbane. Firemen used the fire bell to ring in each New Year.

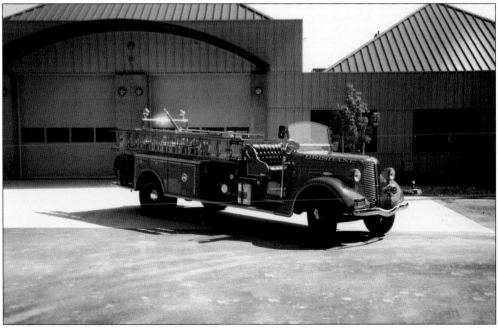

The restored Indiana fire truck stands in front of Brisbane's new fire station, dedicated on May 9, 1992, at the intersection of Valley Drive and Old Bayshore Boulevard. Once used for firefighting, the Indiana truck is now used for special occasions, parades, Day at the Park in October, and, of course, at Christmas to deliver gifts to children of Brisbane.

Enjoying the sun at the minipark in 1965, once the site of Gil's Drug Store, are retirees taking time to relax.

The "Plug Preserve" occupies part of the minipark at the corner of Mariposa Street and Visitacion Avenue. These different-sized fireplugs have been retired and represent famous people and groups.

The brightly painted fire hydrants are a unique display in the minipark at the corner of Visitacion Avenue and Mariposa Street.

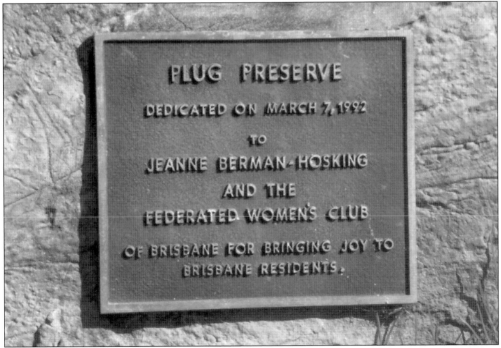

PLUG PRESERVE

DEDICATED ON MARCH 7, 1992

TO

JEANNE BERMAN-HOSKING

AND THE

FEDERATED WOMEN'S CLUB

OF BRISBANE FOR BRINGING JOY TO BRISBANE RESIDENTS.

In 1974, Jeanne Berman-Hosking and Trudi Davis suggested a fire hydrant painting project for the bicentennial of the United States in 1976. They gathered support from the Federated Women's Club, local businesses, and citizens to paint the town's fireplugs to resemble 1776 Revolutionary War heroes. A plaque commemorating this was placed at the Plug Preserve in March 1992.

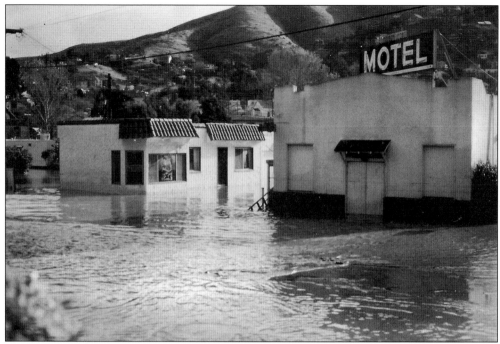

A devastating flood hit Brisbane in January 1982. Rowboats were used to bring trailer park residents to safety. A huge rainfall coincided with the highest tide of the year to close one of the two entrances to town.

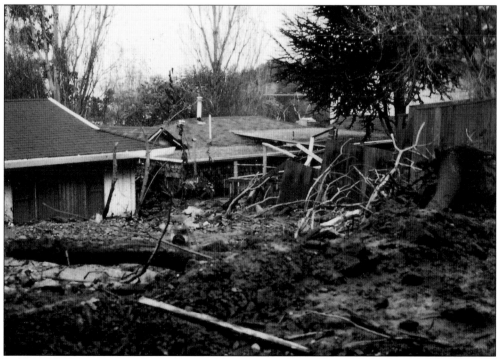

Lena and Ed Mann escaped injury as mud flowed into the back of their home at 416 Sierra Point Road from water-soaked San Bruno Mountain in 1982.

The "Welcome to Brisbane" sign on Old County Road, across from the auto court (now the site of Community Park), was covered in waist-deep water in January 1982.

The "Peace" or "Victory" sign is given by this young man standing waist deep in water on Old County Road in front of Brisbane Village Shopping Center in the frightening 1982 flood.

A great spot to people-watch for Bill Ellison (left), Albert Duro (center), and Leigh Dunning in 1998 was the bench in front of the Brick Oven at 160 Visitacion Avenue.

Flo and Carol's Coffee Shop, at 148 Visitacion Avenue, was a spot where locals went for coffee and breakfast. Owned by friendly sisters Flo Smith and Carol Garibaldi (seen here), Flo and Carol's Coffee Shop was a town favorite from 1983 to 1989.

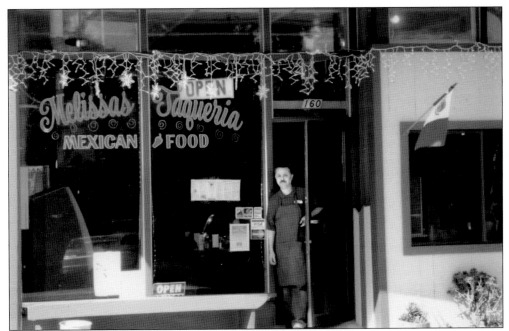

Coming back to Brisbane in 1945 after serving in the U.S. Army, Jimmy Watson and his wife, Dorothy, built the Fountain of Youth, a popular eatery at 160 Visitacion Avenue. Through the years, there have been many diverse restaurants at this location. Standing in the doorway is current owner Raphael Mesa of Melissa's Taqueria.

The Star Box at 33 Visitacion Avenue serves tasty lunches and provides tables outside. Mama Mia Pizza, next door, serves ever-popular pizza. This building has had a variety of tenants over the years, such as food establishments, a radio shop, barber and beauty shops, a real estate office, and in 1942, the library until it moved to 19 San Bruno Avenue.

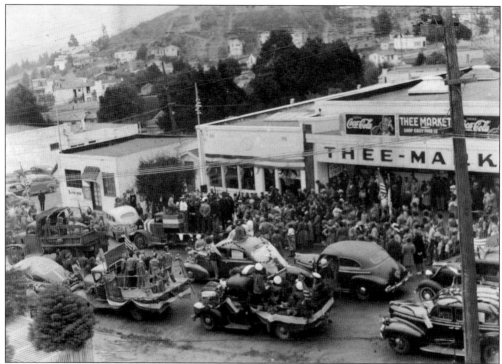

The post office on the corner of Monterey Street and Visitacion Avenue was so small that 10 people would be hard-pressed to enter to check their postal boxes, as there was no home delivery. A letter could be mailed for 3¢. In 1945, the post office moved to this new and larger location (center building) at 245 Visitacion Avenue to accommodate the growing population of Brisbane. Finally residents were pleased to get home delivery of mail in 1949. The first two mail carriers were Harold Tikkanen and Paul Schmidt.

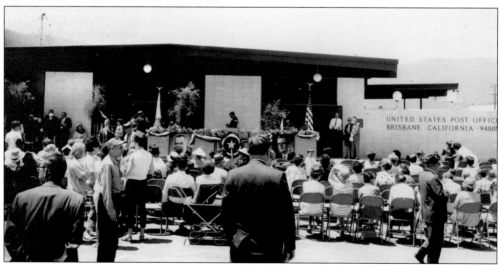

By 1962, the Brisbane Post Office was elevated to first-class status. New businesses, a rising population, and Crocker Industrial Park created a demand for a larger post office. In 1966, the celebration for the new post office was a grand affair with a ceremony that was held outside with chairs for attendees in front of the building at 250 Visitacion Mall.

In 1999, this post office was torn down and a new building for the post office was erected in a nearby location. A road built through the old site allowed needed access directly into Crocker Industrial Park.

After serving in the navy in World War II, John Clancy became first a postman, a clerk, assistant postmaster, and finally served as Brisbane postmaster from 1970 to 1979 while continuing to be a volunteer fireman in Brisbane.

By the 1980s, Sierra Point, which had once been a dumping site for San Francisco garbage, was revitalized by a new office park, one of several in Brisbane. The ominous-looking black building, nicknamed the "Darth Vader building" by locals, was joined by the Dakin building, to the left and behind. The Dakin building, sometimes called the "Skywalker building" in opposition to the Darth Vader building, has won a number of architectural awards and was the site of several meetings between Russians and Americans set up by Henry Dakin, chairman of the Dakin Company, to facilitate "Glasnost" in the waning days of the Soviet Union. (Courtesy of Harry P. Costa.)

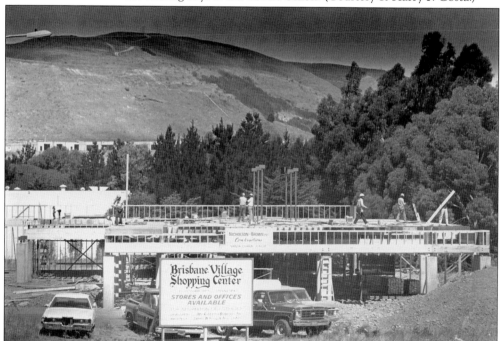

With San Bruno Mountain hovering in the background, the Brisbane Village Shopping Center is under construction here in 1979, giving residents a variety of small shops and more eating locations.

Paved roads made building in the hills of Brisbane easier, and by 1975, most lots were filled. Looking northwest, the radio towers line San Bruno Mountain, which is covered with low foliage.

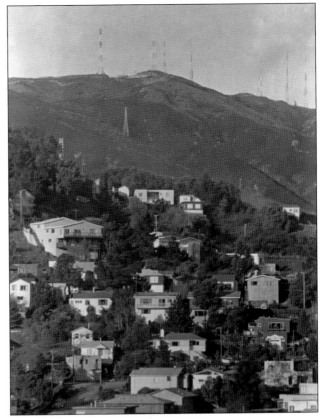

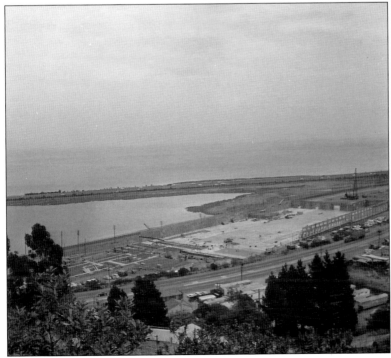

Van Waters and Rogers broke ground for their building at 3745 Bayshore Boulevard in 1962. After the 1906 San Francisco earthquake, this site was used for the debris. Gold pieces were found while excavating.

By the 1980s, Mozzetti's Motel was obsolete, sold and purchased by the City of Brisbane. The Brisbane Fire Department practiced their fire science in 1989 by burning the old dilapidated cabins that were built in 1929. This site is now the Community Park.

The lovely gazebo in the Community Park hosts bands and weddings and provides benches for just relaxing.

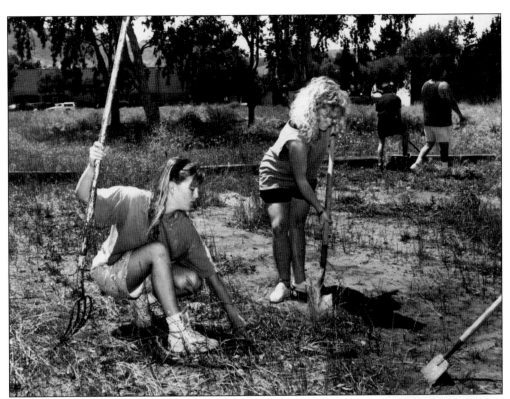

Every year since the early 1990s, many residents plant vegetables and flowers in Brisbane's community garden. (Courtesy of Harry P. Costa.)

This small park at Glen Park Way and Ross Way was named for Dick Firth, former Parks, Beaches, and Recreation commissioner, and dedicated in 1979 for picnics and enjoyment.

Hundreds attended the 25th anniversary of Brisbane's incorporation, November 1986, at the community center, 250 Visitacion Avenue. Celebrants danced to music by Puzzy Firth and enjoyed delicious food, drinks, and an entertaining social evening.

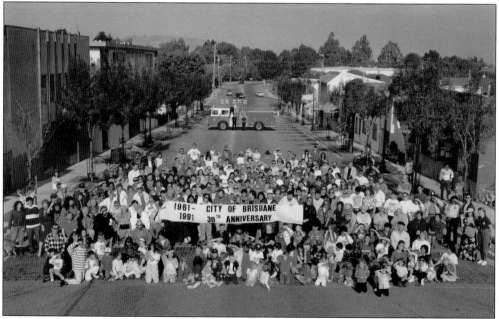

All residents of town were invited to be in this picture in celebration of the 30th anniversary of Brisbane's incorporation, taken at the intersection of Visitacion Avenue and Mariposa Street in 1991.

Brisbane truly becomes "The City of Stars" during the Christmas season; homes nestled by San Bruno Mountain glimmer with bright-colored stars. In 1938, Del Gagnier put the first star on his house at 328 Kings Road at Christmas time. In time, others followed and by 1945, the Brisbane Chamber of Commerce sponsored the stars, some members building them in their yards.

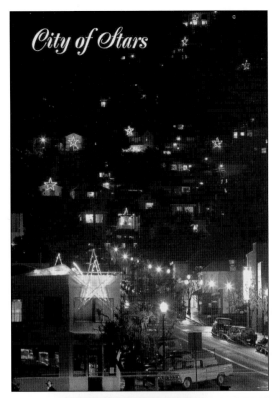

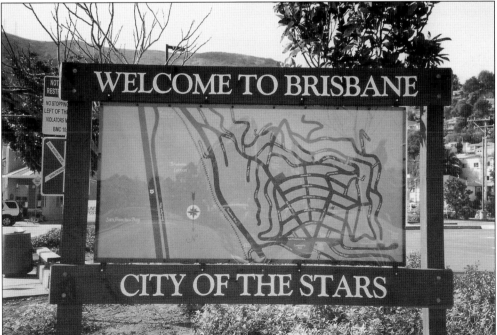

Randy Romriell, with help, totally refurbished the large "Welcome to Brisbane" sign that now stands in front of the post office at the corner of Visitacion Avenue and Old County Road. This took over a year to complete. Dale Conway helped Romriell to set the sign in concrete in 2008.

www.arcadiapublishing.com

Discover books about the town where you grew up, the cities where your friends and families live, the town where your parents met, or even that retirement spot you've been dreaming about. Our Web site provides history lovers with exclusive deals, advanced notification about new titles, e-mail alerts of author events, and much more.

MADE IN THE USA

Arcadia Publishing, the leading local history publisher in the United States, is committed to making history accessible and meaningful through publishing books that celebrate and preserve the heritage of America's people and places. Consistent with our mission to preserve history on a local level, this book was printed in South Carolina on American-made paper and manufactured entirely in the United States.

This book carries the accredited Forest Stewardship Council (FSC) label and is printed on 100 percent FSC-certified paper. Products carrying the FSC label are independently certified to assure consumers that they come from forests that are managed to meet the social, economic, and ecological needs of present and future generations.

FSC
Mixed Sources
Product group from well-managed
forests and other controlled sources

Cert no. SW-COC-001530
www.fsc.org
© 1996 Forest Stewardship Council

Find Your Place in History.